Paint This with Jerry Yarnell®

Country Scenes in Acrylic

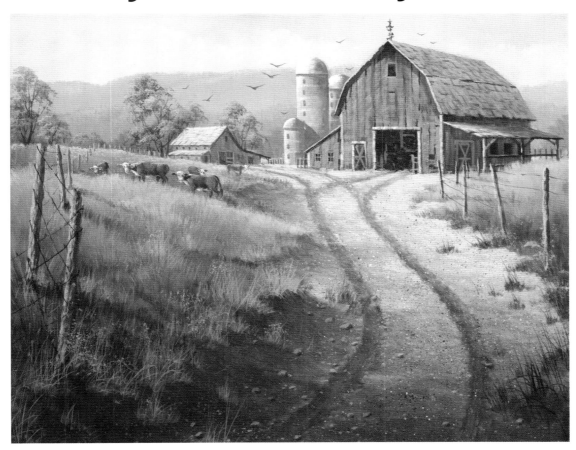

Paint This with Jerry Yarnell®
Country Scenes in Acrylic

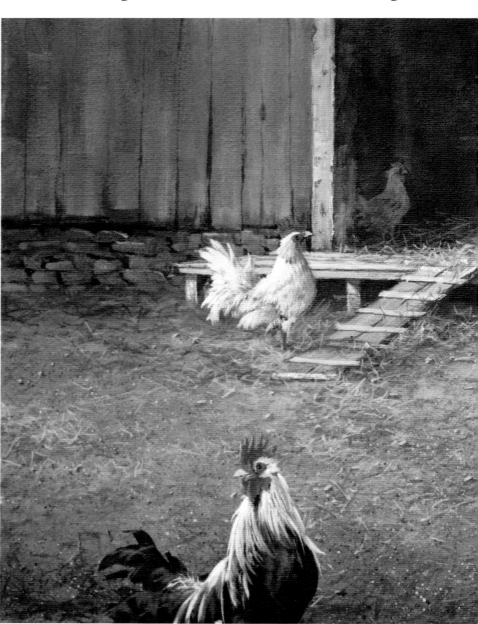

Attention Please!, Acrylic on canvas, 12" × 26" (30cm × 66cm)

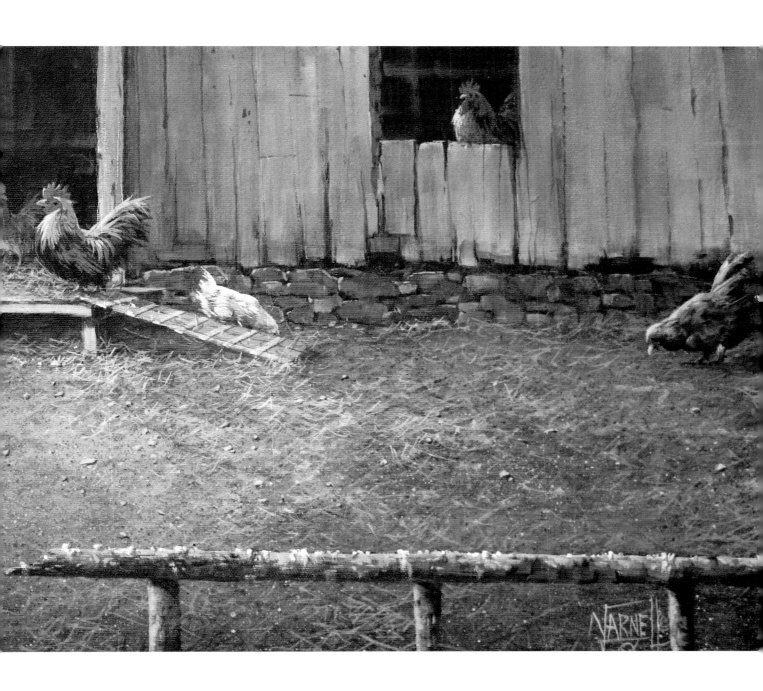

NORTH LIGHT BOOKS

CINCINNATI, OHIO

artistsnetwork.com

Contents

What You Need

SURFACE
stretched canvas

ACRYLIC PIGMENTS
Alizarin Crimson, Burnt Sienna, Burnt Umber, Cadmium Orange, Cadmium Red Deep, Cadmium Red Light, Cadmium Yellow Light, Dioxazine Purple, Hooker's Green, Naphthol Crimson, Phthalo Green, Turquoise Deep, Ultramarine Blue, Vivid Lime Green

BRUSHES
- 2" (51mm) hake
- nos. 2, 4, 6, 10 and 12 bristle flats
- nos. 2, 4, 6 and 10 Dynasty brushes
- no. 4 sable flat
- no. 4 sable round
- no. 4 sable script

OTHER
- medium or firm toothbrush
- paper towels
- soft vine charcoal
- water mister bottle
- white Conté pencil
- white gesso

Blue Door
Acrylic on canvas
16" × 20" (41cm × 51cm)

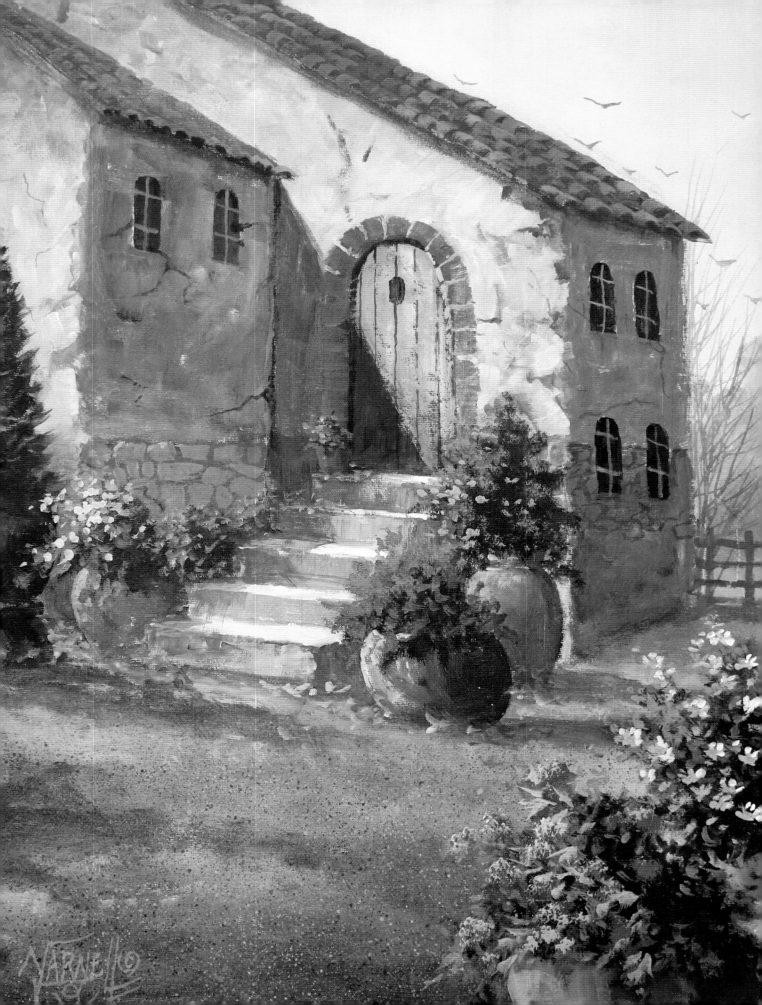

Introduction

In this book, we will explore how to paint country landscapes in different seasons, times of day and color schemes, with various types of buildings and structures included in your composition. And of course, we can't talk about buildings and other man-made architecture without talking about perspective.

I believe it is extremely important for every artist to have at least a foundational understanding of one- and two-point perspective. However, understanding how to use perspective can be somewhat intimidating if you are unfamiliar with the basic concept of how it works. I will do my best to show you the principles of perspective and make them simple for you to understand and use in your landscape paintings.

We will also cover proportion and explore how to place buildings and other structures within the context of a landscape. You will learn techniques for underpainting and detailing buildings as well.

This will be a painting experience I know you'll enjoy. So grab your brushes and paints and get ready to be inspired!

View from Afar
Acrylic on canvas
18" × 24" (41cm × 61cm)

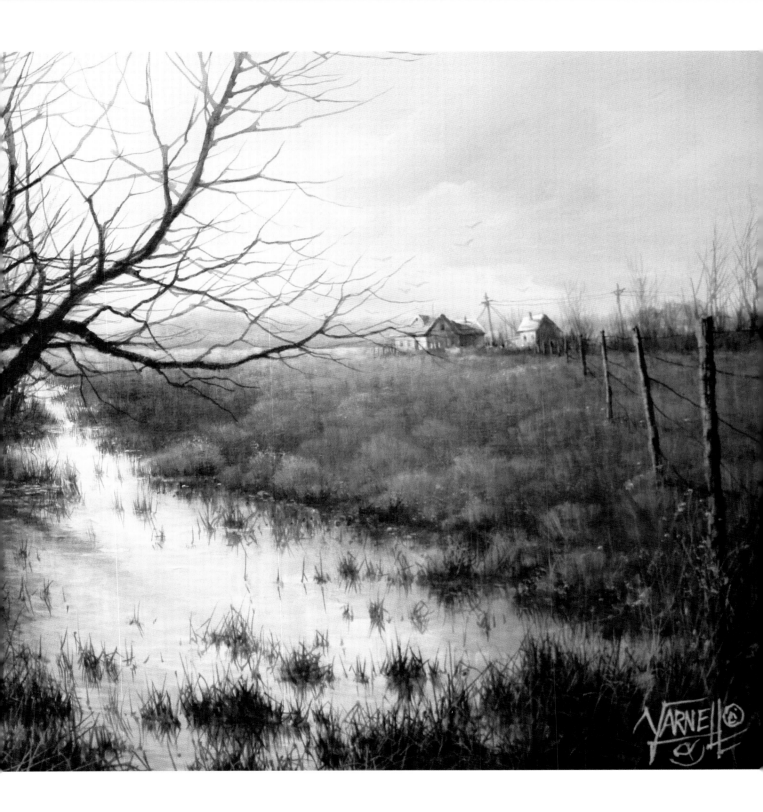

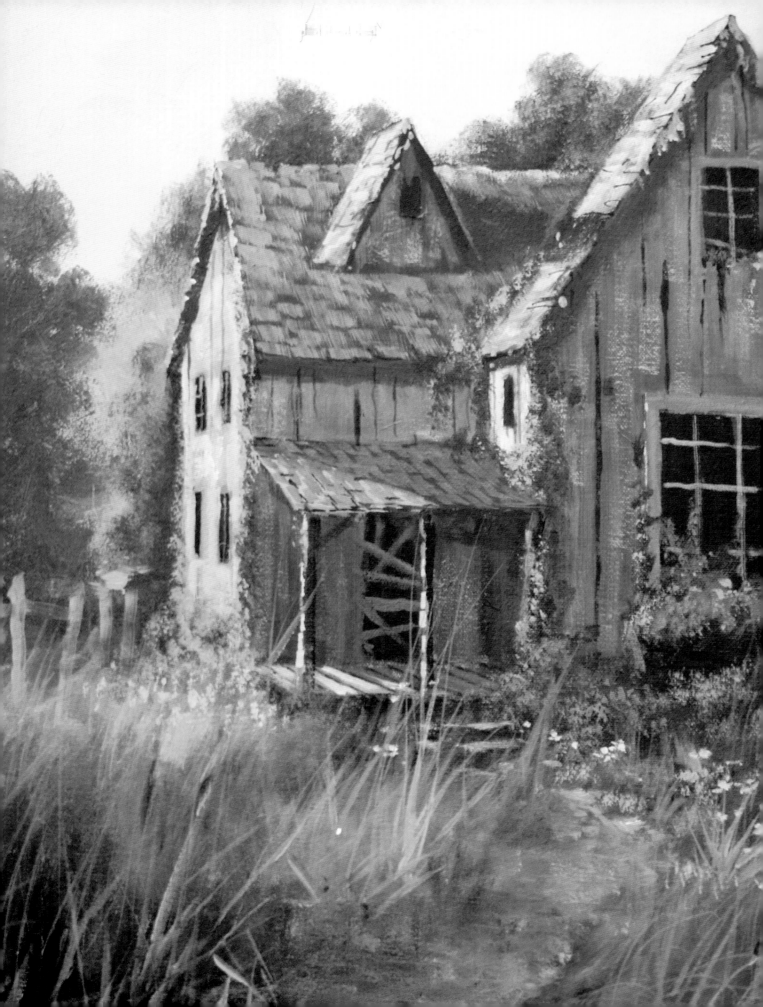

Materials

As the old saying goes: The quality of your project is only as good as the quality of the products you use. As a fine artist, I insist on using the highest quality products that meet archival standards (museum grade). All of the tools and materials covered in this book are professional grade. These supplies can be found in most art stores, except for the brushes. The brushes I use are my own design and can only be purchased from the Yarnell School of Fine Art (yarnellschool.com) or from a Yarnell Certified instructor.

When choosing art supplies, try to purchase professional-grade products when possible. If you are a beginner and still developing your painting skills, or if you have a limited budget to work with, student-grade materials are the next best option. I guarantee that the quality of the materials you use will correlate directly to the ease of your experience learning to paint, producing better art and having a product that will stand the test of time.

Ageless Beauty
Acrylic on canvas
18" × 24" (46cm × 61cm)

Brushes

There is a wide variety of types and sizes of brushes available for artists. To make things simple, the descriptions below cover only those brushes you'll need to complete the paintings in this book.

2" (51MM) HAKE (GOAT HAIR)

Use this brush with acrylics and watercolors only. It is made of goat hair, one of the finest hairs used in paint brushes, so it has a tendency to shed. However, this brush creates beautiful, soft blends over large areas, like skies and water. It also creates mottled backgrounds, such as those used in still life and wildlife paintings.

1½" (30MM) BRISTLE FLAT

All of the paintings in this book were done in acrylic, but the techniques work great for oils as well. If you prefer to work with oils, substitute this brush for the hake when painting glazes, water, skies and other large areas. (Hake brush hairs are too fine for oils.)

NOS. 2, 4, 6, 10 AND 12 BRISTLE FLATS

Thicker-bodied paints like acrylics and oils work best with these brushes. Their coarse bristles are great for brush techniques such as scrubbing and dabbing. They also work well for underpainting backgrounds and adding texture. These are not brushes for fine details.

NOS. 2, 4, 6 AND 10 DYNASTY (CHISEL EDGE)

These well-balanced brushes are made of nylon. When wet, they hold a very sharp chisel edge. This makes them perfect for clean-edged, structured subjects like fence posts, tree trunks,

wooden objects and wood grain. Because of their extreme flexibility, they work well for creating tall weeds, individual leaves and leaf patterns. They make beautiful flower petals for broad-petaled flowers, too.

NO. 4 SABLE FLAT AND NO. 4 SABLE ROUND

These small brushes are perfect for areas of fine detail and for blending soft edges. They work particularly well for close-up details of birds, animals and small foliage patterns. These are fairly delicate brushes, so be careful not to scrub with them or abuse them in any way, or the hairs will bend and separate, making them unusable.

NO. 4 SABLE SCRIPT

Often referred to as a liner brush, this can be used with any medium, as long as the paint is thinned down to an ink-like consistency. It works great for tree limbs, weeds and any other fine-line work.

Jerry Yarnell Signature Acrylic Brush Set (8)
Most types and sizes of brushes can be purchased in art stores, with several brands available to choose from. However, Jerry Yarnell Signature Brushes and brush sets can only be purchased at a Yarnell Certified instructor's workshop or at yarnellschool.com. Sales of brushes appearing to be Jerry Yarnell Signature Brushes via any other source have not been authorized by Jerry Yarnell or the Yarnell Studio & School of Fine Art, LLC.

A: no. 4 sable round; B: no. 6 bristle flat; C: no. 4 bristle flat; D: 2" (51mm) hake; E: no. 10 bristle flat; F: no. 2 bristle; G: no. 4 sable script; H: no. 4 sable flat

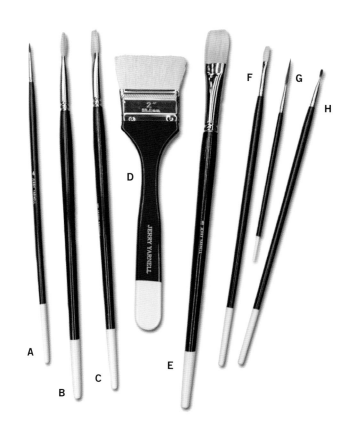

Stedi-Rest System

If you want or need to do a lot of detail work, but you don't have a steady hand, Masterson's Stedi-Rest system can be a real game changer. It is simple to install on your canvas and easy to use. The Stedi-Rest system consists of a plastic strip about 17" (43cm) long with slots that are about ½" (13mm) apart. The slots hold a mahl stick in place, which you can then rest your hand on as you paint. This is a great tool for keeping your hand steady while allowing you to be more comfortable and less fatigued.

Normally you place one Stedi-Rest strip on either side of the canvas to hold the mahl stick in place. However, if you have a lot of very fine close-up detail, you can attach Stedi-Rest strips on two sides of the canvas. Then you can place your mahl stick level across the canvas and slide your hand back and forth as you paint.

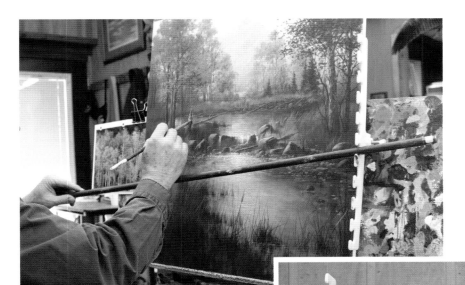

Traditional Use of the Stedi-Rest System
A Stedi-Rest strip is attached to the side of the canvas with a thumb screw. One end of the mahl stick rests in a slot while the artist holds the other end, creating a rest for the hand.

Alternate Use of Stedi-Rest
Stedi-Rest strips have been attached on two sides of the canvas. The mahl stick lays horizontal across the painting to allow for easy back-and-forth hand movement.

Other Materials

Following are descriptions for some other important and useful supplies you will need to complete the painting demonstrations in this book.

SOFT VINE CHARCOAL
This is the preferred sketching material for making rough sketches on canvas. Soft vine charcoal removes easily with a damp paper towel without leaving any residue. NOTE: I do not recommend you use hard-lead pencils or hard charcoal sticks for sketching as they are more difficult to remove and often leave marks or residue.

CONTÉ SOFT PASTEL PENCILS
These pencils are a soft French pastel in pencil form. They are soft but can still be sharpened to a fairly sharp point for more delicate sketches, like birds, people, animals, etc. Also, they can be easily erased.

PALETTE KNIFE
Palette knives come in multiple types and have many uses. Some artists paint with them, some apply texture with them, some sculpt with them, but most of us just need a palette knife to mix our colors. A good mixing knife should be flexible with a trowel-shaped handle. It should have about a 3"–4" (8cm–10cm) mixing blade with a handle about 7"–8" (18cm–20cm) long. You can buy plastic or metal knives. I prefer a metal knife because it is more flexible and durable.

MAHL STICK
A mahl stick is nothing more than a long dowel rod about 36" (91cm) long that you rest along the side of the canvas or use with the Stedi-Rest system to steady your hand for detail work. You can buy very expensive metal or wood mahl sticks, or you can go to your local hardware or craft store and buy a wooden dowel rod for a dollar or two. Some of my students prefer a metal, collapsible mahl stick, which can be folded up neatly for packing or travel.

FINE-GRIT SANDPAPER
I use a fine-grit sandpaper for lightly sanding my bare canvas to knock down the tooth and any flaws. You can also use fine-grit sandpaper for lightly sanding brush hairs off of your finished painting.

TOOTHBRUSH
Yes, a toothbrush. It works great for more than brushing your teeth. You can use one to create sand, snowflakes, mist, splashes at the base of a waterfall, small pebbles, dirt and gravel. Throughout the book you will see most of these applications explained.

Palette Knife

White Conté Pencil

Studio Setup

Your studio setup might not seem terribly important; however, in my own experience, an improper studio setup can make the painting process unnecessarily difficult. Everything from proper lighting to the kind of chair you sit in can make a huge difference in the quality of your work and your artistic mood. Of course, not everyone can afford a large, professional studio, so here are a few tips for those who are short on space and money.

- If possible, find a space that is large enough for you to be able to stand at least 6 feet (2m) back from your work.
- Use a wooden or aluminum easel that is stable and does not wiggle or move around as you work. I use the Stanrite 500 aluminum easel. It is very sturdy, yet lightweight, and folds up easily for transportation.
- If all you have room for is a table-top easel, that's OK. Just be sure it is heavy duty, and attach it to your table to keep it from moving around. There is nothing more frustrating than an easel that won't stay in place!
- Good lighting is essential. A standard lamp, or even a headlight, is not sufficient to give you even lighting without casting shadows. I prefer to hang two 4 foot (122cm)

double-bulb fluorescent lights about 2 feet (61cm) above my easel. I put a warm light bulb and a cool light bulb on each fixture to simulate daylight and cut down on shadows. This arrangement provides an even distribution of light.
- I recommend a good, comfortable padded chair with a high back and rollers. That way you can easily roll back and view your work. I use an executive high-back office chair with adjustable arms and seat height.
- If you prefer to stand, you may want a padded stool to lean back on. Also, standing on a cushioned mat will help cut down on fatigue and achy joints.

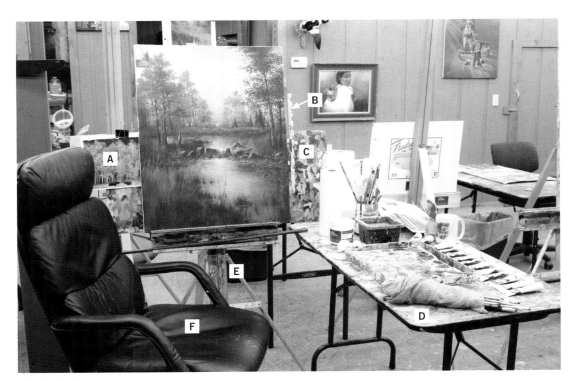

My Studio Setup
A: reference material; B: Stedi-Rest system; C: dabble board; D: supplies table, E: Stanrite aluminum easel; F: comfortable padded chair with wheels

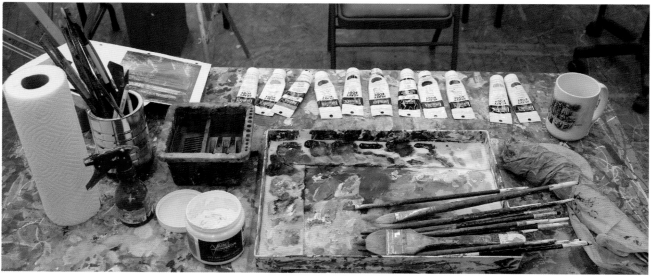

Supplies Setup

I strongly recommend placing a large table next to your easel to keep all of your supplies organized and within easy reach.

Dabble Board

Every artist needs a dabble board. A dabble board is nothing more than a canvas board for testing colors and mixtures on. I usually set mine on the easel so I can slide it back and forth behind the painting.

Tip If you are unable to install the recommended type of lighting because of limited space, you can purchase a light known as an OttLite. These are made specifically for artists and can be clipped onto your easel or used as a free-standing pole lamp.

Organizing & Storing Reference Materials

In this age of modern technology, there are seemingly endless options for researching and storing reference materials, including smartphones, digital cameras, computers, tablets and so on. While these are all great resources, most require a power source, so they are not always convenient to use. My experience has taught me that most artists prefer to use physical copies of reference photos that can be marked and held close to the easel as they work.

I have been using the same reference system for thirty years, and it works very well for providing quick access to reference for the subjects you need to compose your painting. Below are some tips that can help you organize and use your research material more effectively. You will need:

- 3-ring binders (Use any size you wish. I prefer 1"–1½" [3cm–4cm].)
- 8½" × 11" (22cm × 28cm) card stock/index paper
- 3-hole punch
- Transparent scotch tape or Elmer's glue (Don't use glue sticks. They dry out, and the photos come loose.)
- Markers or a label-maker
- Reinforcement labels for the punched holes
- Scissors or craft knife for trimming photos
- Tab dividers to separate categories within the books
- Reference photos

Once you have gathered all of your materials, separate your photos into categories (i.e., Birds, Animals, Rocks, Mountains, Rivers, Trees, etc.), then label each book with that category and a number.

Trim your photos to fit the card stock. Tape them in place on the front and back. I recommend keeping similar subjects together on the same page. Write the number of the book at the bottom of each page. This will be especially helpful when you are working on a painting that has multiple reference sheets. Finally, put the reference sheet back in the binder with the same number. This saves time and confusion when re-filing your reference material.

Simply place your books and/or categories in alphabetical order, and you'll be ready to begin researching when it's time to start your next painting.

Organizing Reference Material
The labels and numbers on the reference photo pages match the label and number on the spine of the binder.

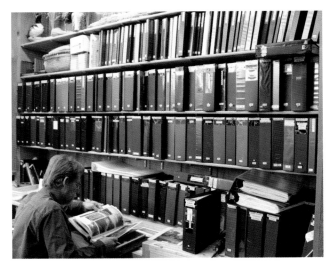

Jerry and His Massive Research Library
All binders are labeled, numbered and in alphabetical order, which makes them easy both to locate and re-file.

Techniques

A technique is the process you use to achieve a specific effect. Throughout this book, you will hear me use terms like scumbling, drybrush, feathering, underpainting, graying, dabbing and so on. These are all techniques used to create atmosphere, depth, texture and blending.

This chapter explores the various concepts and techniques you will need to apply to complete the painting demonstrations that follow. In addition, it offers advice and tips for color mixing, using perspective accurately and developing your composition. You will gain a solid foundation for all of the basics required to create a beautiful landscape painting.

Back from the Garden
Acrylic on canvas
18" × 24" (46cm × 61cm)

Terms

The following terms are used throughout this book to describe various painting methods and techniques. If you familiarize yourself with these terms now, it will help make the painting process a bit easier.

ACCENT HIGHLIGHT

The finishing highlight that brings the tonal value up to its full light value. It is usually two or three values lighter than the form highlight.

DABBING

A brush technique that can be used to create leaves, ground cover, flowers and texture. Dab the tip of a bristle brush on a table or palette until it fans out, then load the paint and begin dabbing the brush tip on the canvas to create the desired effect.

DOUBLE LOAD/TRIPLE LOAD

A blending process where more than one color is applied to different parts of the brush tip, then mixed directly on the canvas instead of on a palette. This works great for mottled objects like rocks and dirt, as well as certain still-life objects in cases where a pre-mixed color or value is not as important.

DRY-BRUSH BLENDING

Also known as feather blending, this brush technique can be used to apply soft highlights, details and multiple layers of glaze. Any type of brush will work for this, depending on the object and size of the area you are painting. Simply use a small amount of paint and very light pressure to gently skim across the tooth of the canvas and leave a soft highlight. Dry-brush blending usually requires multiple layers to achieve the brightness you desire.

FORM HIGHLIGHT

This highlight is only about one to two values brighter than the underpainting. I often use this term after an object has been underpainted and is ready for the first dimensional highlights that establish its basic form.

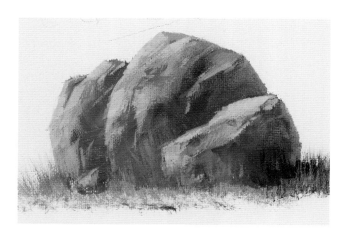

Accent Highlight with Final Details

Form Highlight

GLAZING

Also known as a wash, this process uses a very thin mixture of water with just enough pigment to create a soft tint. A glaze or wash is usually applied with a hake brush, but other brushes such as large bristle flats can also be used. Glazes have a slightly milky tint, which makes them useful for tinting an entire painting, creating softness or atmosphere in certain areas of a painting, toning down objects that are too bright or creating fog, mist, haze and smoke.

NEGATIVE SPACE

There are two types of negative space: outer negative space and inner negative space. Outer negative space consists of the pockets of negative space that surround an object and give it form. Inner negative space is pockets of space that form the inner areas of the object.

SCRUBBING

A brush technique used for underpainting and highlighting objects like rocks, trees and dirt. It is usually done with a bristle brush and heavier pressure to create a basic rough form and form highlights. It should not be used for detailing or other finishing work—only for basic form building.

SCUMBLING

A brush technique used for creating various objects such as clumps of leaves and other foliage, clouds, curly hair and grasses. It is nothing more than a series of unorganized, overlapping strokes that create the suggestion of a form. It also works great for creating mottled backgrounds. Scumbling can be done with any size and type of brush.

VALUE

The relative lightness or darkness of a color. Value is used to create depth, distance and dimensional form.

WET-ON-DRY

A paint layering technique where you allow the area you've just painted to dry completely before applying the next layer of paint. This is the layering technique I use most often in my own acrylic painting, especially for highlights and details.

WET-IN-WET

A technique used to layer and blend paint simultaneously. The next layer of paint is applied while the first layer is still wet, then the shadows and highlights are blended together. This technique works well for creating clouds, rocks or any other area that needs dimensional blending.

UNDERPAINTING (BLOCKING IN)

The process used to establish the darker areas of a painting to prepare them for the later layers of highlights and details.

Underpainting (Blocking In)

Value

A proper value system is a crucial component of a painting. Before you can master how to mix and use values, you must first understand that there are two different types of value systems.

CREATING DEPTH

The first type of value is value used to create depth or distance in a painting, specifically a landscape with multiple layers of hills and trees. The general rule for creating depth in a painting is that objects in the background are cooler in tone, less intense in color, softer, less detailed and lighter in value. As you move into the foreground, objects become gradually warmer in tone, more intense in color, more detailed and darker in value.

CREATING FORM

The second type of value is value used to create the form or dimensional shape of an object. A standard form value system consists of at least three values: dark value, middle value and light value. Of course, there will be gradation values between each of these to transition one into another. These transitional values allow the eye to flow gracefully across or around an object so that there are no hard or defined edges.

Below are examples of value changes in a normal landscape. Most landscapes will have between three and seven value changes. It all depends on the time of day, the direction of the light source and the amount of depth you want to achieve. The general rule is that the more value changes you have, the more depth you will create.

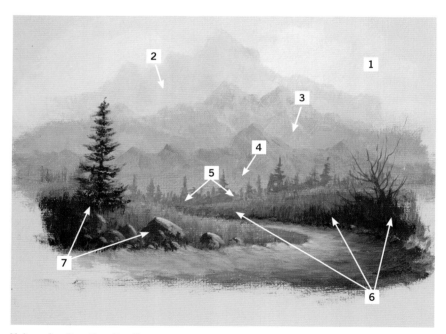

Values for Creating Depth
Value 1: sky; Values 2, 3, 4: distant mountains; Value 5: distant pine trees; Value 6: middle-ground objects; Value 7: foreground objects

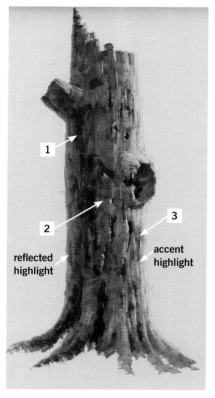

Values for Creating Form
Value 1: dark; Value 2: medium; Value 3: light; accent highlight; reflected highlight

The Grayscale

The grayscale is a system artists use to determine the intensity or value of a color. Most art schools require students to create and study the grayscale before they are allowed to begin working with full color. Students create simple black-and-white paintings with multiple values suggesting depth (distance) in a landscape or in the dimensional form of an object.

This system works for every color and color mixture you can create. For the painting demonstrations in this book, you'll find the grayscale below extremely helpful in determining the proper intensity of all the color formulas I have provided.

For example, if I recommend using a medium value dark green mixture, all you have to do is add just enough white to the Dark Green formula (1 part Hooker's Green + ¼ part Dioxazine Purple) to change the value to match the medium value on the grayscale. It's that simple!

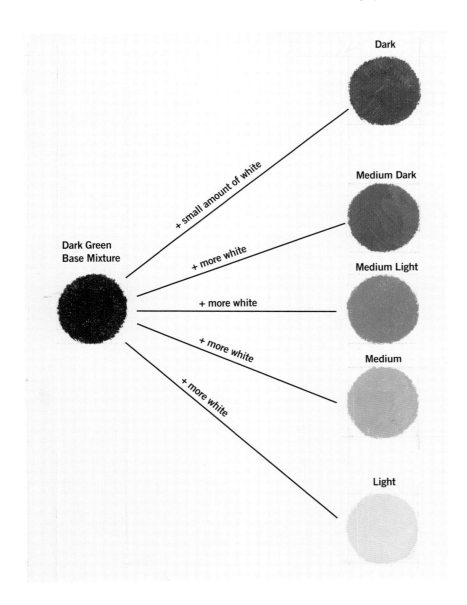

Dark

Medium Dark

Medium Light

Medium

Light

+ small amount of white

+ more white

+ more white

+ more white

+ more white

Dark Green Base Mixture

Use the Grayscale to Change the Value of a Basic Mixture by Adding White
Only use this system to change the value of a color mixture. Depending on the painting, time of day, location of the light source or season, you may have to slightly alter the color or value.

Color Mixing

The following basic color formulas and mixtures can be used for a wide range of paintings, including all of the painting demonstrations in this book.

MIXING BLACKS

Many artists use black paint right out of the tube. However, this tends to be a lifeless black, so I recommend mixing your own blacks. The best thing about mixing your own blacks is that you can vary the temperature and hue.

After you create a black mixture, it can be difficult to know exactly what hue the black is. To see the hue, simply add a small amount of white to the edge of the mix, and the color will instantly appear. This is a great method for testing hues and makes it easy to adjust your color as needed.

Even after you have created a basic black mixture, you can still add other colors to change the hue or temperature. For example, to make a black warmer, add more Burnt Sienna or some other warm color. To make a black cooler, add more Ultramarine Blue or other cool color.

Let's take a look at a few of my most commonly used black mixtures.

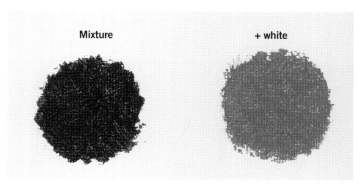

Basic Black Formula

Mix 1 part Burnt Sienna and ½ part Ultramarine Blue. This simple mixture creates a generic black for multiple applications. In its dark form it is neither warm nor cool, and when tested with white, it turns into a nice neutral gray. This mixture has many uses because of its neutral tone.

Black With Turquoise Tint Formula

Mix equal parts Burnt Umber and Turquoise Deep. This creates a black that is rich, deep and soft. It is deeper in tone than the basic black formula, but when you test it with white, you'll notice it has a slight greenish tint.

Midnight Black Formula

Mix 1 part Burnt Umber, 1 part Turquoise Deep and ¼ part Dioxazine Purple. This creates an exciting, dark black that works especially well for a midnight sky. Although this mixture is similar to the first two formulas, it has some purple in it.

MIXING COLORS

You can use these basic color mixtures as the foundation for many paintings. Of course, any of these can be changed based on your particular color scheme. Be open-minded and willing to make adjustments as needed.

Dark Green Formula
Mix 1 part Hooker's Green, ⅛ part Dioxazine Purple and ⅛ part Burnt Sienna. This creates a deep forest green that can be used for underpainting leaves, grasses, bushes and meadows.

Medium Green Formula
Mix 1 part Hooker's Green with ¼ part Cadmium Orange and a touch of Cadmium Yellow Light. This creates a medium green that can be used for middle-tone highlights on leaves, grasses, bushes and meadows.

Light Green Formula
Mix 1 part Vivid Lime Green with touches of Cadmium Orange and Cadmium Yellow Light. This creates an accent or final highlights on leaves, grasses, bushes and meadows.

Basic Gray Formula
Mix 1 part Burnt Sienna and ¼ part Ultramarine Blue with a touch of Dioxazine Purple and white. This creates a basic gray that can be used for underpainting rocks, tree trunks, mountains, wooden objects and animals.

Mixture · + white

Dark Brown Formula

Mix 1 part Hooker's Green with ¼ part Alizarin Crimson and a touch of Cadmium Orange. This creates a basic brown that can be used for underpainting warm, dark autumn tones on dirt banks, rocks, tree trunks, leaves or bushes.

Mixture · + white

Medium Brown Formula

Mix 1 part of the Dark Brown formula with touches of Cadmium Yellow Light and Dioxazine Purple. This creates a basic tan that can be used for underpainting sand, dirt, animals and other areas of the painting that require a soft, warm, light undertone.

Mixture · + white

Light Brown Formula

Mix 1 part white with ⅛ part Cadmium Orange and a touch of Ultramarine Blue. This creates a basic color for accent and final highlights to be used for most structures like rocks, tree trunks, mountains, wooden objects and some animals.

Mixture · + white

Basic Purple Formula

Mix 1 part white with ¼ part Dioxazine Purple and ¼ part Ultramarine Blue. This creates a reflected highlight tone for the accent highlight on the shadowed side of rounded objects like rocks, tree trunks, fence posts and body parts. This mixture is specifically designed to soften the hard edges of the shadows of these objects.

Mixture · + white

Basic Blue Formula

Mix 1 part Turquoise Deep with ⅛ part Ultramarine Blue and ⅛ part Burnt Umber. This creates a basic mixture for underpainting lakes, ponds, streams and other deep bodies of water.

Mixture · + white

Pale Flesh Tone Formula

Mix 1 part white with touches of Cadmium Orange and the Basic Gray formula. This creates a basic highlight color for highlighting most objects after the form highlight has been applied.

Graying a Color

If you need to kill the purity of a color, you can gray it down by mixing in a touch of its complementary color. For example, if you're using yellow as an accent or highlight and it's too bright for that area of the painting, neutralize it by adding a touch of its complement, purple. Or let's say you have a blue-gray mixture that is too strong. You could gray it by adding a touch of Cadmium Orange or some form of an orange mixture.

Cadmium Yellow Light + Complement Purple

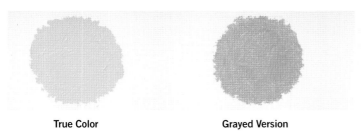

True Color · Grayed Version

Dioxazine Purple + Complement Yellow

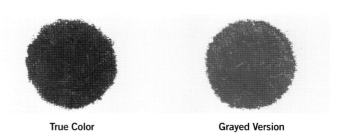

True Color · Grayed Version

Cadmium Orange + Complement Blue

True Color · Grayed Version

Ultramarine Blue + Complement Orange

True Color · Grayed Version

Cadmium Red Light + Complement Green

True Color · Grayed Version

Hooker's Green + Complement Red

True Color · Grayed Version

Graying Your Canvas

Although you can purchase canvases that are pre-primed with white gesso and ready to paint on, most professional artists prefer to use a neutral canvas with either a warm or cool grayish base. Stark white is a distraction to color; gray is a neutral tone to which the eye adjusts easily. The purpose of a gray canvas is to kill the white surface so you can see colors and values better.

This same principle applies to your palette, too. Many people make fun of my dirty palette, until they try one and see how well it works.

The following mixtures are the basic gray tints I use for graying my canvas.

Warm Gray Canvas Tint
Mix 1 part gesso, ¼ part Burnt Umber and ⅛ part Ultramarine Blue.

Cool Gray Canvas Tint
Mix 1 part gesso, ¼ part Ultramarine Blue and ⅛ part Burnt Umber.

Mauvish-Gray Canvas Tint
Begin with either the warm gray or cool gray formula and add a little bit of Dioxazine Purple.

Greenish-Gray Canvas Tint
Begin with either the warm gray or cool gray formula and add a little bit of Hooker's Green.

Anatomy of Painting

Paintings are kind of like the human body. Both are made up of many parts. The body has a head, a neck, a torso, arms, legs and feet. You can look at a painting in a similar way. The illustration below shows you how to break your landscape painting down into various segments so you can create better distance and depth in your artwork.

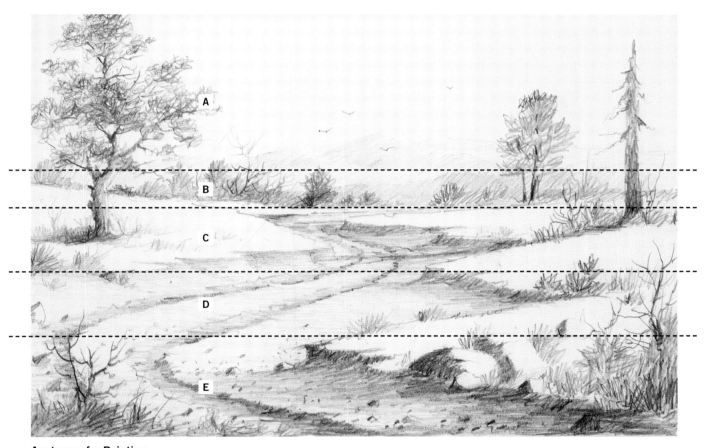

Anatomy of a Painting
A: background; B: middle background; C: middle ground; D: middle foreground; E: foreground

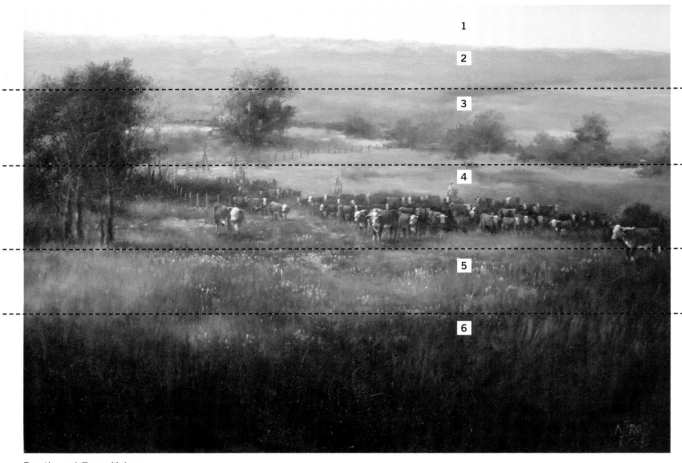

Depth and Form Values

1–2: sky and distant objects (hills, trees); 3: miscellaneous distant trees; 4: center of interest (cattle); 5: miscellaneous details (flowers, grasses); 6: immediate foreground objects

Order of Segments		Approximate Value Number per Segment
1–2	Background	1
3	Middle Ground	2–3
4	Center of Interest (Middle Ground)	4–5
5	Middle Foreground	6
6	Immediate Foreground	7

Tip

Most full-scale landscapes have between three and seven value changes that coincide with these segments of the painting. Each painting has its own value system based on time of day, atmosphere, season, light source and so on. Use lighter values in the background and darker values as you move into the foreground. Keep an open mind and do not be afraid to use your artistic license to achieve the effect you want.

Composition & Design

Composition is the arrangement of objects, subjects and ground contours on your canvas to create graceful eye flow without bouncing from object to object or getting hung up on distractions. It is the most important element in creating any type of artwork. It is truly the foundation of the creative process.

The very first art award I ever won was because my painting had a strong composition. The judge said to me, "I am giving you first place not because I like your painting so much—frankly, it is not painted very well. However, the composition is so strong that it drew me in and held my attention, and my conscience won't allow me not to give you the first place award." For me, it was a career-changing moment that confirmed just how critical composition is.

So let's take a look at some of the key elements of composition that should be present in all of your paintings. We will only cover the basics, but this should give you an understanding of how everything works together in unison to create a well-balanced piece of art.

CENTER OF INTEREST OR FOCAL AREA

All artwork needs a center of interest or focal area. The center of interest is the object that attracts the eye and holds the viewer's attention. It can be a single object or a tightly grouped series of objects. The purpose is to get the viewer to see the object/objects as the most important part of the painting. Everything else in the painting should be non-competitive and serve to guide the viewer's eye toward the center of interest.

A focal area also draws in and holds the viewer's attention, but it is not typically an object. Rather, it might be a beautiful sunset with rays reflecting on a lake or ocean or a winding pathway or road leading back to a beautiful waterfall or snow-capped mountains in the distance—these are all focal points. Everything else is just filler leading the eye toward the focal area.

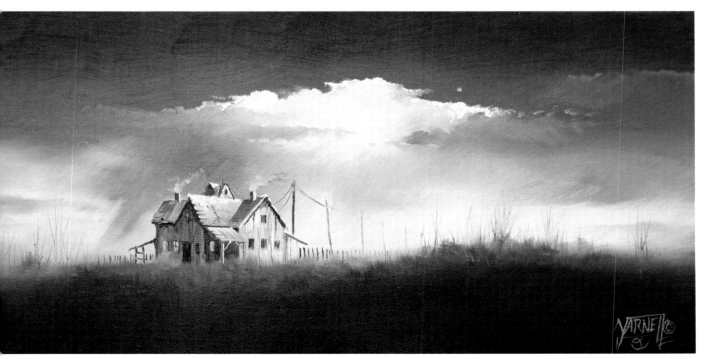

Center of Interest
A center of Interest is created by arranging all the land masses and other segments of the painting—roads, pathways, cloud formations, mountains, rivers, etc.—all leading to the center of interest. In this painting the cloud formations create a canopy and shaft of light that surrounds and holds your eye on the old farm house.

Prairie Magic
Acrylic on canvas
12" × 24" (30cm × 61cm)

EYE STOPPERS

Eye stoppers are generally located in the lower corners or at the sides of a painting. They stop the eye from wandering off the canvas. These are usually non-competitive fillers like tall weeds, small, twiggy bushes, rocks or trees with limbs painted toward the focal area of the composition. Even simple dark shadows in the corners with no detail can work as eye stoppers sometimes.

NEGATIVE SPACE

There are two types of negative space. Outer negative space surrounds an object and gives it form. Inner negative space is the space or spaces within an object that give the object detail. The pockets of space in the canopy of a leafy tree or bush, the folds and wrinkles in material or cracks and crevices in a rock or mountain are examples of inner negative space.

FILLERS

Fillers are the objects that fill up the areas around the focal area. These are the items that complete the painting and help guide the viewer's eye toward the focal area or center of interest without competing with the main areas of interest. They can also be used to help define the season, time of day, atmosphere and so on. Examples of fillers include trees, bushes, meadows, water, dirt, rocks, distant hills or mountains and weeds. Just remember, they serve only to support the focal area, not compete with it.

LIGHT SOURCE AND SHADOWS

Every composition has a pre-determined light source. This is important because the location of the light source will cast shadows that greatly affect the compositional eye flow. For instance, bright sunlight creates shorter, softer shadows; low sunlight creates longer, more intense shadows. Choose what works best for your painting.

OVERLAPPING

Overlapping is when you have multiple smaller objects grouped together and arranged so they overlap each another. This creates pockets of negative space and helps eye flow, as opposed to lining up objects all in a row, evenly spaced and similarly shaped.

PLANES AND PROPORTIONS

Use planes to add individual, proportional objects throughout a painting. For example, if you have an object on the right side of the painting and want to add another object of the same proportion on the left side, draw a horizontal/parallel line from the base of the object all the way across the canvas. That is the plane. Now any object you paint on that plane, using what we call "artistic common sense," should be in proportion to everything else on that plane.

Poor Use of Negative Space
There are no interesting pockets of negative space within the tree leaves, so the viewer's eye zips around the image instead of flowing gracefully.

Good Use of Negative Space
Pockets of negative space placed throughout the tree leaves add interest and create good eye flow.

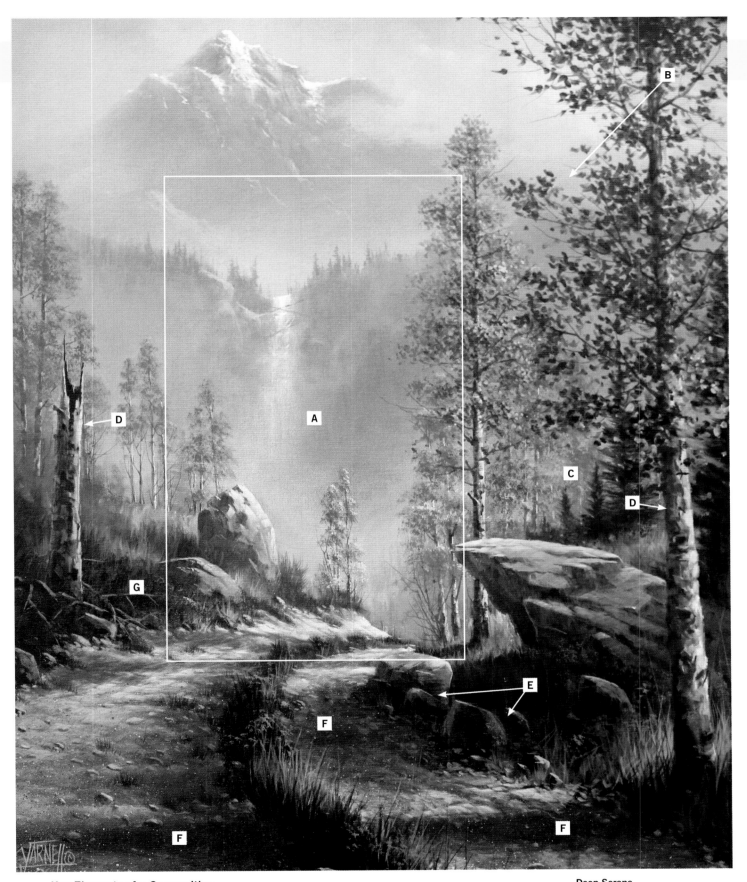

Key Elements of a Composition

A: focal area; B: light source; C: good use of negative space; D: eye stopper; E: overlapping objects;
F: cast shadows; G: fillers

Deep Serene
Acrylic on canvas
12" × 10" (30cm × 25cm)

Perspective

Perspective is the process we use to determine the correct angles and proportions of houses, barns and other objects like windows, doors, roofs, porches, sidewalks, chimneys, steps, fence posts, telephone poles, rows of bricks and other man-made structures.

Another purpose for using perspective is to create depth by having multiple objects like buildings, fence posts, telephone poles and such that are lined up in a row and recede into the distance toward the horizon.

There are many complicated forms of perspective that architects and engineers use to determine multiple angles for buildings and other objects. However, for most of us who paint the simpler buildings and structures in traditional landscape paintings, the basic one- or two-point perspective process is perfect and easy to understand.

ONE-POINT PERSPECTIVE

Use this to determine the angle, height and proportion of one side of a building or object.

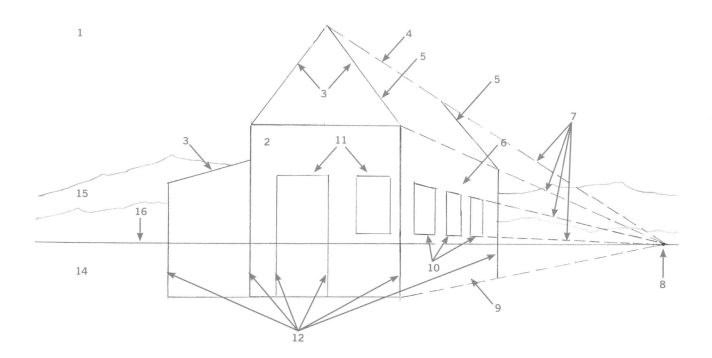

Perspective Terminology
1: sky; 2: non-perspected side of building; 3: non-perspected roof pitch; 4: perspected roof lines; 5: non-perspected parallel lines; 6: perspected side of building; 7: vanishing lines; 8: vanishing point; 9: perspected base; 10: perspected windows; 11: non-perspected door and window; 12: non-perspected parallel lines; 13: foreground; 14: middle ground; 15: background; 16: horizon line

TWO-POINT PERSPECTIVE

Use this to determine the angle, height and proportion on two sides of a building or object.

HORIZON LINE

This is the area in your painting where the sky and land masses meet. It is where you place your vanishing points, and it's the point at which the vanishing lines recede. A horizon is always level and can be placed anywhere in your painting depending on the angle, height, proportion and location of the object being perspected.

VANISHING POINT(S)

These are designated points placed on the horizon line where all the vanishing lines that come from a perspected building or object meet. You may have one or two vanishing points depending on whether you are using one- or two-point perspective. Vanishing points can be located anywhere along the horizon depending on the degree of angle, proportion or height of the building being perspected. You can have multiple vanishing points if you have multiple buildings being perspected.

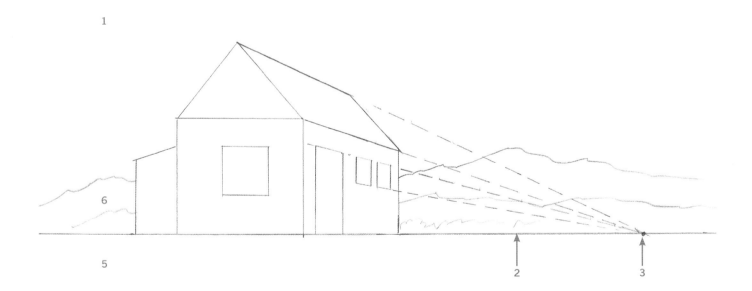

One-Point Perspective, Building at Eye Level

For an object or building at eye level that is level on the ground, select the desired location on the horizon line, then use the principles of one- and two-point perspective to place and proportion the building. In this example, the horizon line doubles as a vanishing line for the base of the building because it sits at eye level.

1: sky; 2: horizon line; 3: vanishing point; 4: foreground; 5: middle ground; 6: background

PARALLEL LINES

These are perspected lines that correspond to each other in an equal direction. Usually they are opposite each other like the roof lines or corners of the building. They help your building stand up straight.

OTHER USES FOR ONE- AND TWO-POINT PERSPECTIVE

- A building or object sitting at eye level on level ground (like a prairie) will sit directly on the horizon line.
- A building or object sitting on an incline or hillside will sit somewhere above the horizon line. All vanishing lines will be perspected downward to the vanishing point on the horizon line. You will usually need a low horizon line for this angle.

- A building or object that appears to be in a valley (as though you are standing on an elevation above the building) must be placed below the horizon line with all vanishing lines perspected upward to the vanishing point. You will usually need a high horizon line for this angle.
- The most common location for an object or building is partially above and partially below the horizon. It does not matter how much of the building is above or below the horizon. This gives you the freedom to create many different compositions.

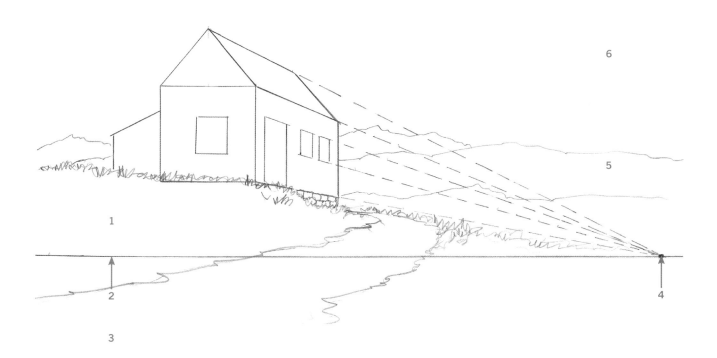

One-Point Perspective, Building on a Hillside

For an object or building located on a hillside, place the building in the desired location above the horizon, then use the principles of one- or two-point perspective to properly proportion the building.

1: middle ground; 2: horizon line; 3: foreground; 4: vanishing point; 5: background; 6: sky

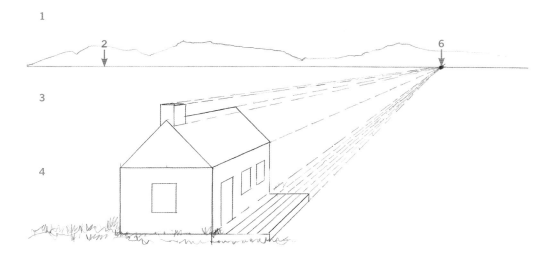

One-Point Perspective, Building in a Valley

For an object or building in a valley, place the building at your desired location below the horizon line, then use the principles of one- or two-point perspective to proportion the building.

1: sky; 2: horizon line; 3: background; 4: middle ground; 5: foreground; 6: vanishing point

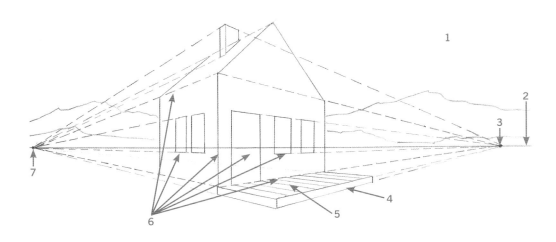

Two-Point Perspective

For two-point perspective, place the building or object at your desired location partially above and partially below the horizon line.

1: sky; 2: horizon line; 3: right vanishing point; 4: front of porch (angles to the right of the vanishing point); 5: porch floor (angled to the left of the vanishing point); 6: perspected lines (those left of the corner go to the left vanishing point, those right of the corner go to the right vanishing point; 7: left vanishing point

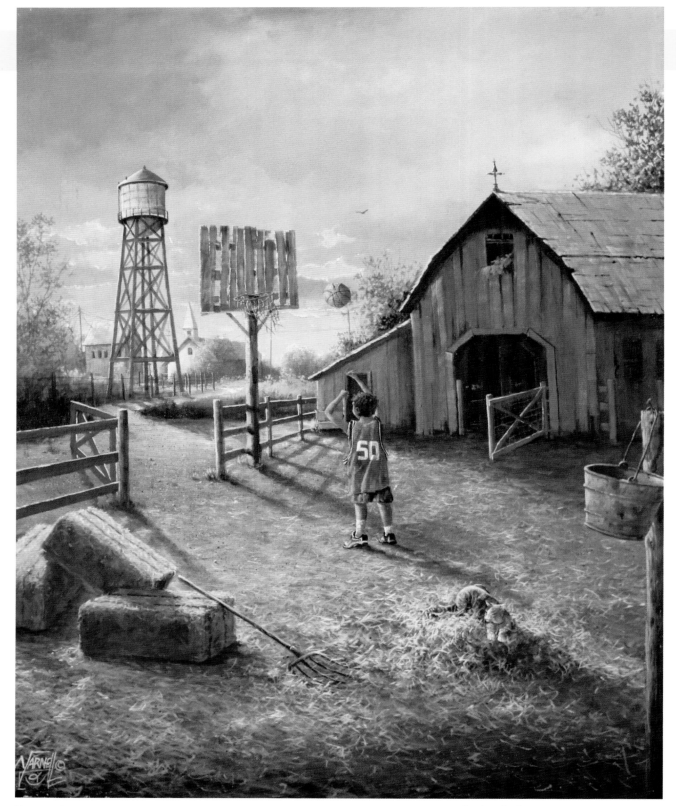

Perspective Angles and Vanishing Points

All the man-made elements of this painting including the barn, basketball hoop, fence, water tower, etc., have perspective angles, which means all the angles lead back to the horizon line. Each object has its own vanishing point on the horizon line that defines the angles and proportions of the object. The barn and water tower are two-point perspected objects. The fence and basketball hoop are one-point perspected objects and share the same vanishing point because they are on the same plane with each other.

Back to the Country
Acrylic on canvas
16" × 20" (41cm × 51cm)

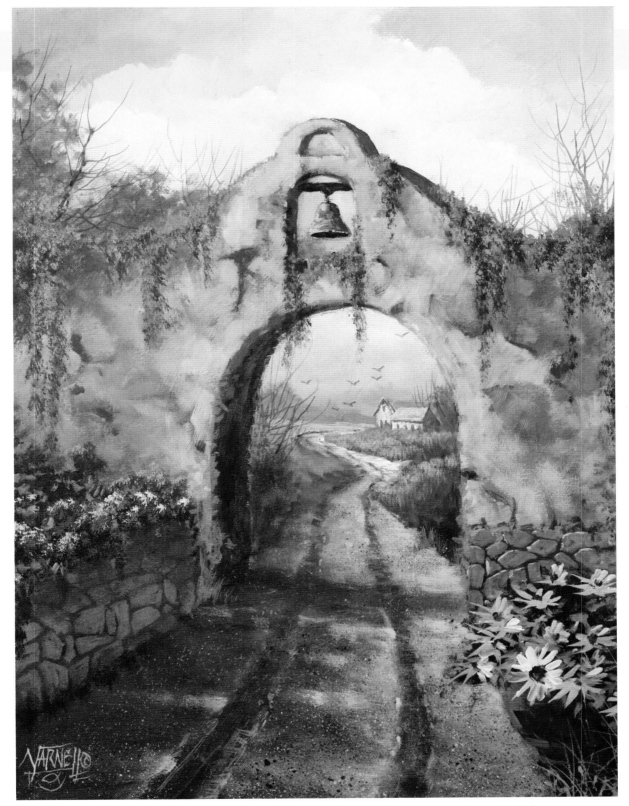

Principles of Perspective at Play

In this painting, the stone wall and the inside shadow of the archway are one-point perspected objects and share the same vanishing point on the horizon line. The small houses in the distance are two-point perspected objects and have their own vanishing points that determine the angle of the roofs and sides. The road is not truly perspected because it has no vanishing point. However, it does follow the main principles of perspective, getting smaller, closer together and less intense in value, color and detail as it recedes into the distance.

Beyond the Wall
Acrylic on canvas
18" × 24" (41cm × 61cm)

Paint Effects

SPLATTERING

Of all the techniques I have used and taught over the years, one of my favorites is splattering with a toothbrush. You can do amazing things with toothbrush splatters. With a ninty-nine-cent toothbrush, you can create an endless array of effects that a forty-dollar paintbrush can't even come close to creating.

You can create paint splatters in various sizes, depending on your subject and desired effect. It is all determined by the amount of water you mix with the paint, your distance from the canvas, the angle of the toothbrush, the amount of paint on the brush and the stiffness of the bristles. (I once made a mist so fine that it looked like an airbrush had been used!)

Here are just a few of the effects you can create with the splatter technique:

- snowflakes
- sand
- mist
- fog
- pebbles
- details in wood
- rain drops
- dew drops
- flowers

So grab a scrap of canvas and a couple of toothbrushes. Practice, practice, practice until you become proficient. You do not want to risk messing up your painting with a bunch of rogue splatters.

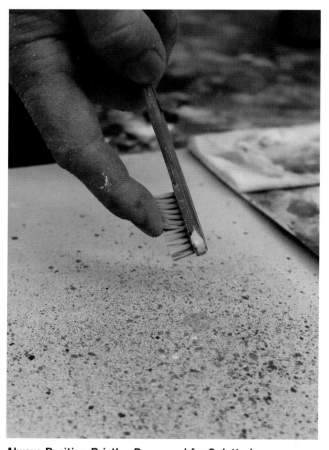

Always Position Bristles Downward for Splattering

Make sure you position the toothbrush properly. Use your forefinger with the brush facing down, toward the canvas. Do not use your thumb with the brush facing up or you will splatter your face.

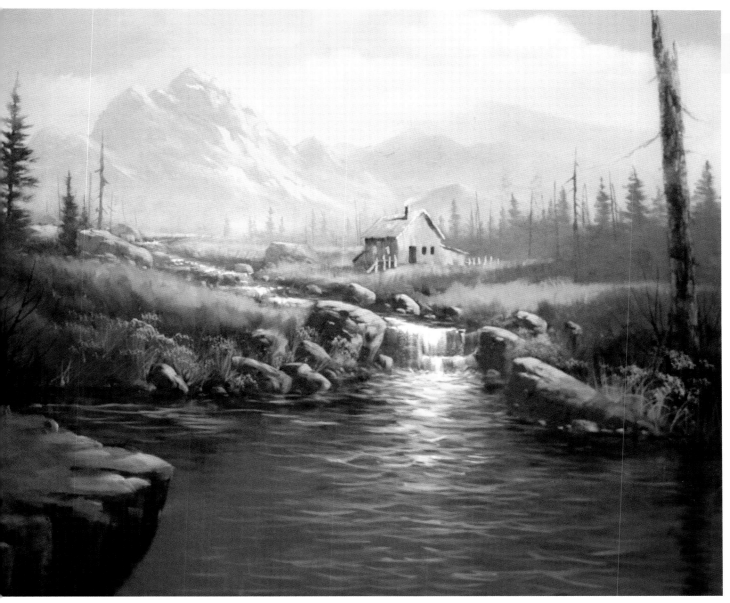

Oil Over Acrylic
This painting is an example of an acrylic underpainting with an oil overpainting. It was completed in about half the time it would have taken to complete using traditional oil techniques, yet it maintains the same quality as an oil piece. Give it a try—you might like it!

PAINTING OIL OVER ACRYLIC

It may surprise you to learn that some artists use oils on top of acrylics in their paintings. But for many artists who use this technique, including myself at times, it's a real time saver. I love to do a beautiful oil painting, but in my early career I didn't do many because of the long drying time between layers of oil. With this technique, however, you can block in and underpaint the main components of the painting and work out color, composition, design, perspective and other technical issues with acrylic. Because of the quick drying time for acrylics, you can paint right on top of the acrylic underpainting with oil almost immediately rather than having to wait several days for it to dry.

Tip Although you can layer oil paint on top of acrylic, this process will not work the other way around. This is mainly because of the way the binders in the pigments attach to the surface they're applied to. The acrylic binders will not adhere to an oil surface very well, creating a risk that the paint will peel off over time.

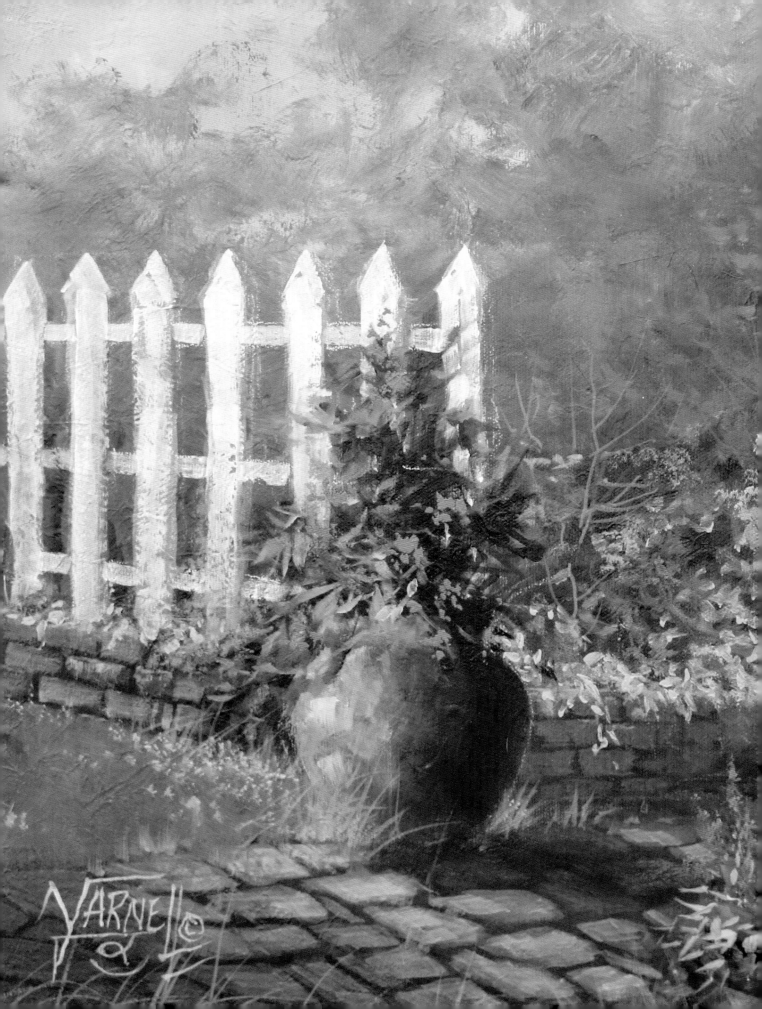

Spring & Summer

Spring and summer are remarkable times of the year. The smells, sounds, textures and colors all add up to a magical time. To an artist, these seasons are all the more meaningful because they trigger an emotional response that inspires the creative process.

In this chapter, you will have the opportunity to put all your artistic skills to use. Your creative side will come alive and you will get lots of practice using technical tools such as composition, perspective, value, color mixing and many others.

We have a lot to cover, so grab your brushes and prepare for a wonderful creative learning opportunity.

Colorful Gateway
Acrylic on gallery-wrap canvas
16" × 20" (41cm × 51cm)

Paint a Country Cottage

STONE PATHWAY

We live in a busy, shrinking world where peace and quiet are becoming more and more difficult to find. I cannot help but think about simpler times and places, like a quiet country lane in the Spring, or a quaint neighborhood lined with simple cottages, picket fences and budding flower gardens. Although it is becoming increasingly difficult to find these places and moments in time, as an artist you can re-discover them on your canvas anytime you want.

In this painting we will do just that. The old cottage surrounded by flower beds, a stone pathway that pulls you in and the whitewashed picket fence make this painting not only challenging, but full of exciting learning opportunities. Prepare to slow down and smell the roses—and to be inspired.

Materials

SURFACE
16" × 20"
(41cm × 51cm)
stretched canvas

ACRYLIC PIGMENTS
Burnt Sienna, Burnt Umber, Cadmium Orange, Cadmium Red Light, Cadmium Yellow Light, Dioxazine Purple, Hooker's Green, Turquoise Deep, Ultramarine Blue, Vivid Lime Green

BRUSHES
- 2" (51mm) hake
- nos. 4 and 6 bristle flats
- nos. 2, 4 and 6 Dynasty
- no. 4 sable flat
- no. 4 sable round
- no. 4 sable script

OTHER
- medium or firm toothbrush
- soft vine charcoal
- white Conté pencil
- white gesso

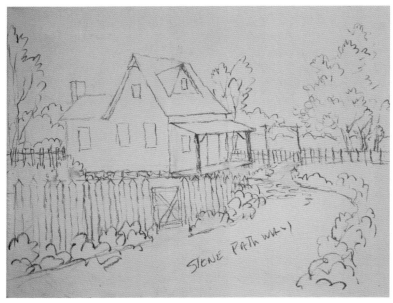

1 Prepare the Canvas and Sketch the Composition

Apply a warm gray tint to the canvas with a 2" (51mm) hake brush. Once dry, use soft vine charcoal to make a rough and loose yet fairly accurate sketch of the main components of the composition. There is a lot of activity in this painting, so it's important to document the basic shape, size, proportion and location of the most important elements. Since much of the sketch will disappear as you underpaint, I recommend taking a picture so you can refer to your original sketch throughout the painting process.

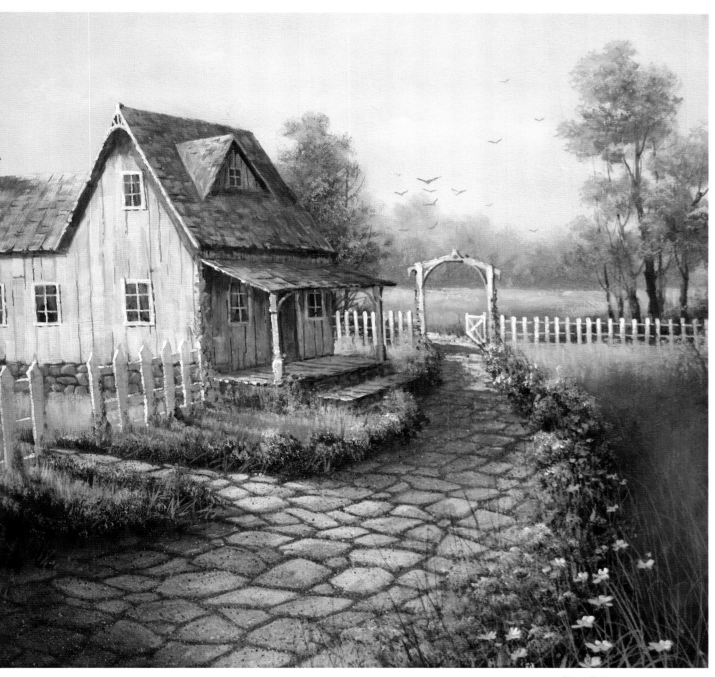

Stone Pathway
Acrylic on canvas
16" × 20" (41cm × 51cm)

Tip If you prefer to follow a finished sketch as you go along, you can create a more detailed sketch on a sketch pad for reference.

2 Begin the Sky

Mix white with touches of Turquoise Deep and Ultramarine Blue to a creamy consistency. This should be a very pale, soft light tint. Use a 2" (51mm) hake brush to apply an even coat of the paint mixture across the background for the sky. Be sure you cover it evenly with large overlapping "X" brushstrokes.

If you feel like the paint is too dry and is not blending well, add just enough water to make it a buttery consistency. Be careful not to add too much water.

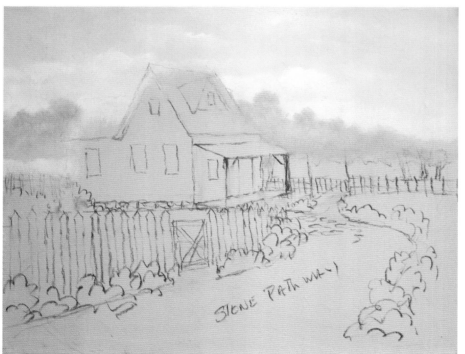

3 Paint the Clouds and Begin the Distant Trees

Mix a small amount of white with a slight touch of Cadmium Red Light. This is only a tint, so be careful not to add too much red or it will overwhelm the tonal value of the sky. Scrub in some clouds across the sky with a no. 4 bristle flat. Keep them soft and simple.

Using the same brush, create a soft mauvish-gray tone by mixing white with touches of Dioxazine Purple, Ultramarine Blue and Burnt Sienna. Scrub in soft, simple tree shapes along the horizon line.

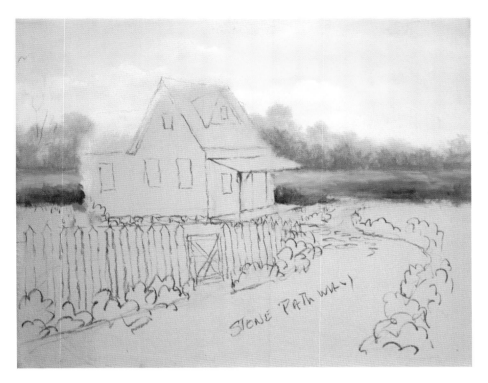

4 Build Up the Distant Trees and Block In the Meadow

Add touches of Hooker's Green and Dioxazine Purple to the color mixture you used for the distant trees. This will darken it by about two values. Use your no. 4 bristle flat to scrub in the suggestion of more trees and bushes at the base of the trees you just painted.

Double-load the same brush with Hooker's Green and Cadmium Yellow Light. Scrub in meadow grasses across the mid-ground with long, choppy, horizontal brushstrokes. Do not over-blend or smooth this out too much as you'll want to be able to see the light and dark areas.

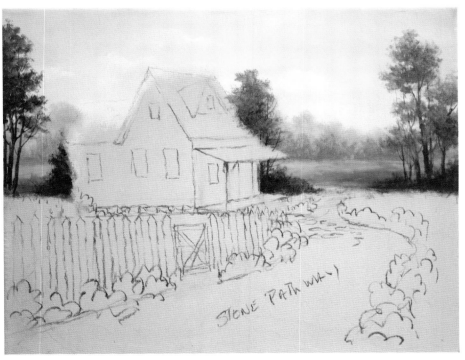

5 Underpaint the Mid-Ground Trees

Mix Ultramarine Blue with a touch of Burnt Sienna and just enough white to create a medium value. Thin it to an ink-like consistency and use a no. 4 sable script to paint in the trunks of the trees.

Mix Hooker's Green with a touch of Dioxazine Purple. Add a slight touch of Cadmium Orange to warm it. If the mixture is very dark, add a small amount of white to create a medium-dark value. Use a no. 4 bristle flat to scumble and scrub in the canopy of the trees. Be sure to keep the edges soft and create interesting pockets of negative space, leaving sky-holes throughout the canopy. You will highlight these in a later step.

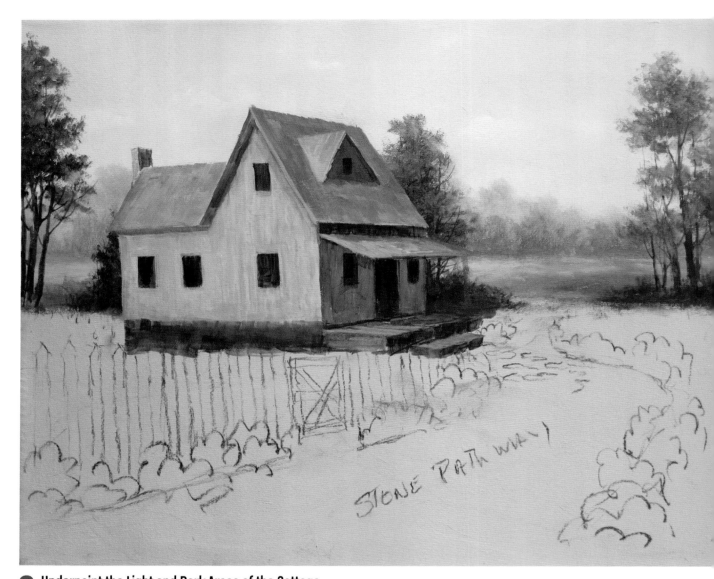

6 Underpaint the Light and Dark Areas of the Cottage

Since this is going to be a white cottage, you'll want to underpaint in various shades and values of gray. Create a creamy medium-dark gray by mixing 1 part Ultramarine Blue with ¼ part Burnt Sienna and just enough white to create the proper value. Use nos. 2, 4 and 6 Dynasty brushes to underpaint the walls, roof and windows. Then create a dark mixture of 1 part Burnt Umber and 1 part Ultramarine Blue and paint in the door. Keep in mind that the sunlight is coming from the left side, so be sure to adjust the values accordingly to represent the sunlit side of the cottage.

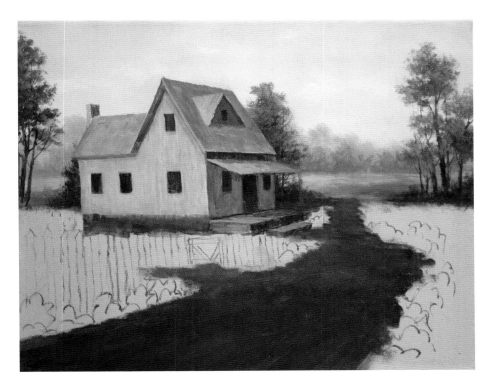

7 Underpaint the Pathway

Mix 3 parts Burnt Umber and 1 part Ultramarine Blue with just enough white to create the medium-dark warm gray. Paint in the entire pathway with a no. 6 bristle flat. Make sure to cover the canvas well and to keep the edges of the path soft and smudgy.

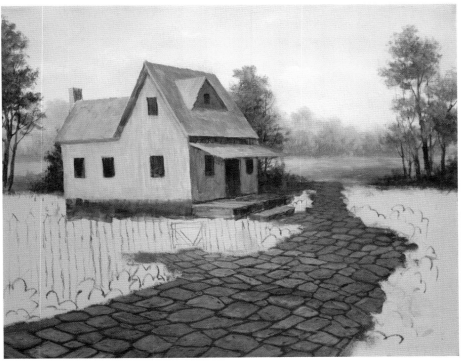

8 Underpaint the Stones

Mix white with a touch of Cadmium Orange and thin it to a fluid consistency. Paint in the shape of each stone with a no. 2 Dynasty brush. The stones should be larger in the foreground and gradually smaller as they recede. Be sure to make them elliptical in shape—this will ensure that the pathway appears flat. (This part of the process will take a while.)

The paint will dry a little darker because of the underpainting coming through—that's okay. If it dries really bright, then your mixture is too opaque and/or you have too much on your brush. Keep thinning it until it is almost a glaze.

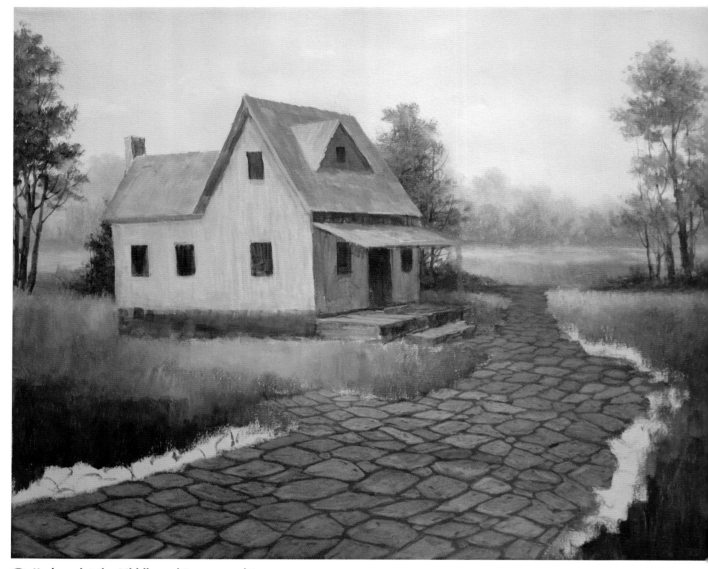

9 Underpaint the Middle and Foreground Grass

Mix 3 parts Hooker's Green with 1 part Cadmium Yellow Light and a touch of Cadmium Orange to create a rich, warm green. Paint in the grassy areas of the middle ground and foreground with a no. 4 or no. 6 bristle flat. Use short vertical brushstrokes to apply the paint. Where the grass is lighter, add a bit more Cadmium Yellow Light. Where it's darker or in shadow, add a touch of Dioxazine Purple. You may add more color later.

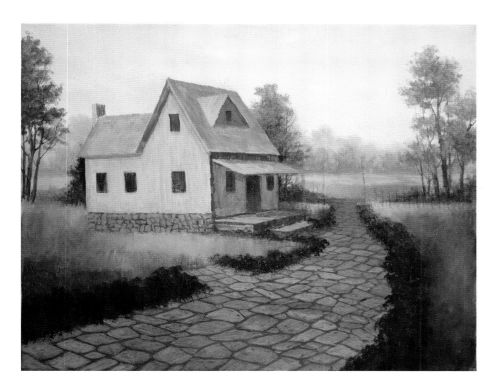

10 Underpaint the Foundation and Block In More Foliage

Mix Burnt Umber with a touch of Cadmium Orange and white. Block in the stones of the foundation with a no. 4 sable flat. Then mix Hooker's Green with a little bit of Dioxazine Purple to darken it. Dab in the shape of the foliage along the pathway with a no. 6 bristle flat.

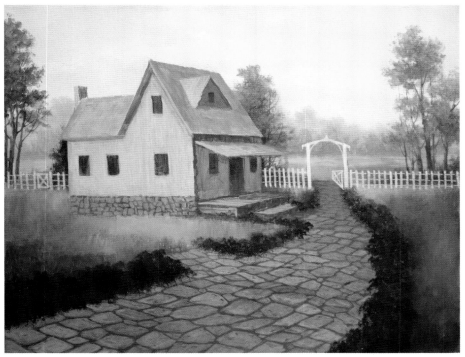

11 Paint the Distant Fence

Tint some white with a touch of Burnt Umber and thin it to a creamy consistency. Use a no. 4 sable script or a no. 4 sable round to paint in the gate and each picket of the distant fence. You may find it easier to lightly sketch in the fence with a white Conté pencil first. However, if you are confident with your brush control, go ahead and paint the fence in without a sketch.

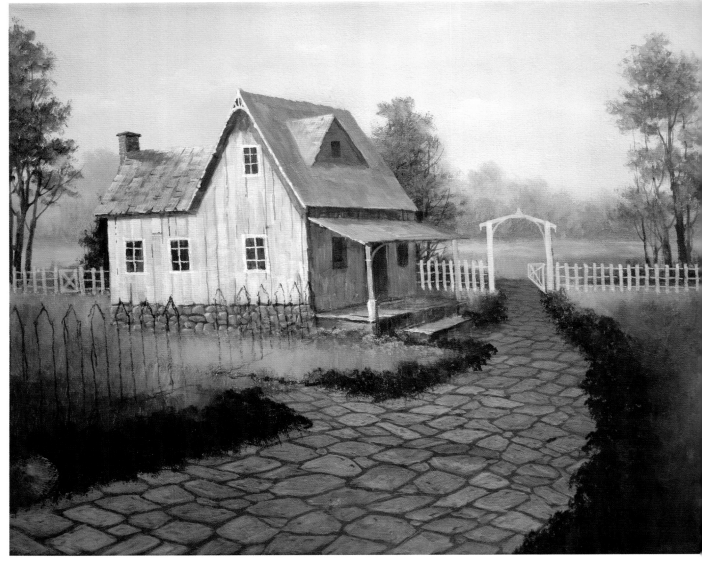

12 Highlight and Detail the Left Side of the Cottage

Create a creamy mixture of white with a touch of Cadmium Orange. Load the tip of a no. 2 Dynasty brush and drybrush vertical strokes on the left wall to suggest weathered wood. You may need to repeat this step several times to achieve the brightness you desire.

Add a little Burnt Sienna and Cadmium Orange to the mixture to give it a warm reddish tint. Drybrush the suggestions of shingles on the roof. Then thin the color slightly and add a little white. Highlight the stone foundation and paint a reddish tone on the sunlit side of the chimney. Darken it slightly for the shadow.

Switch to a no. 4 sable script and paint the dark cracks. Then use white with a touch of Cadmium Orange to highlight the roof edge, porch post and other miscellaneous areas.

Sketch in the stone entry and the fence pickets to the left of the cottage with soft vine charcoal.

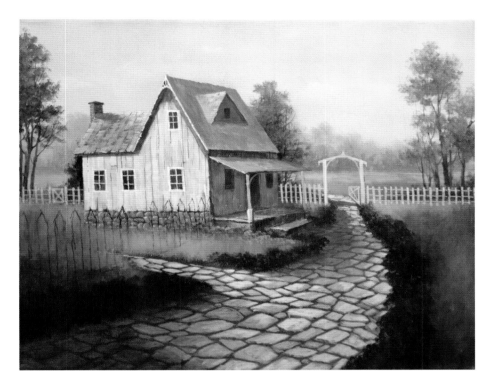

13 Highlight the Stones

Mix white with a touch of Cadmium Orange to create a soft highlight base. Thin it to almost a glaze, but keep it slightly opaque. Then add any other colors to the mix you like, such as Burnt Umber, Burnt Sienna, Cadmium Yellow Light or even Cadmium Red Light. Highlight each stone with these different tones using either a no. 2 Dynasty brush or a no. 4 sable flat. You may need to repeat this step two or three times to achieve the brightness you want.

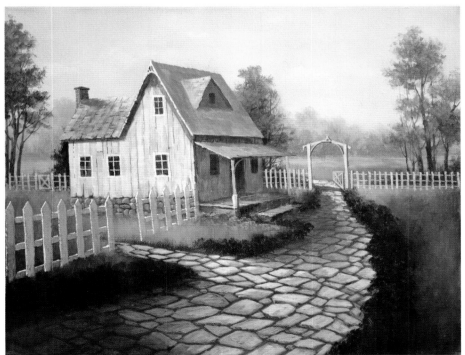

14 Paint the Closest Fence

I suggest using soft vine charcoal or a white Contè pencil to make a more accurate sketch of each fence picket before you begin painting them in.

Since this is the shadowed side of the fence, you'll want to create a creamy medium-light gray mixture of Ultramarine Blue with a touch of Burnt Sienna and just enough white to get the proper value. Paint in the pickets with a no. 2 Dynasty brush. Then mix white with a touch of Cadmium Orange, load the tip of a no. 4 sable script and apply a small sliver of sunlight to the left side of each picket.

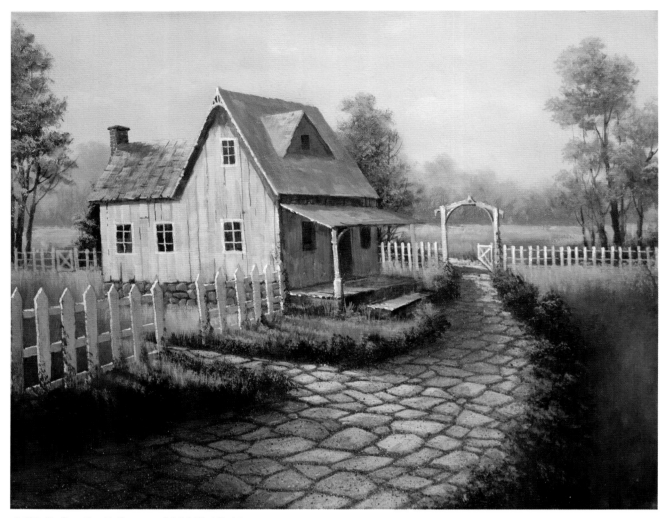

15 Refine the Foliage and Add Highlights

Double-load a no. 4 bristle flat with Hooker's Green and a slight touch of Dioxazine Purple. Go through the painting and begin re-shaping the foliage along the pathway, cottage and fence with this darker green tone. Be sure to add the shadows cast from the fence pickets. Then lighten the mixture with Cadmium Yellow Light and dab in some intermediate highlights to help establish basic form and sunlight.

Use a medium or firm toothbrush to splatter very fine light and dark specks on the pathway. Keep in mind that you're not trying to create rocks or pebbles, just the suggestion of small gravel, sand, dirt, etc. This creates a bit of detail and highlight on the stones.

Mix Vivid Lime Green with a touch of Cadmium Yellow Light and load it onto a no. 4 bristle flat. Dab highlights on the trees to give them dimensional form. You can adjust the color by adding more Cadmium Yellow Light, Vivid Lime Green or a touch of white. Highlight the grasses as bright as you like.

Tip Test the splatter effect on a scrap of canvas first so you can adjust the color and size of the splatters according to your preference. The thinner the mixture, the bigger the splatters will be. I strongly recommend practicing this technique frequently until you become proficient with the process.

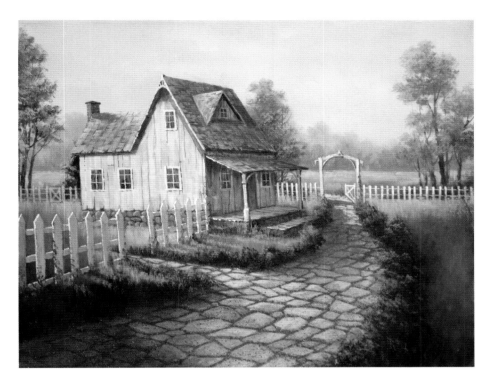

16 Finish the Roof and Cottage Details

Finish the details and highlights on the cottage. Don't be afraid to use your artistic license. Just remember that the right side of the house is in shadow, so be careful not to over highlight, except for the left post, corner of the porch, dormer roof and edges of the roof. (All of these areas will have sunlight.)

For the roof, mix Burnt Sienna with a touch of Burnt Umber and just enough white to lighten the value to a soft medium rust tone. Load a no. 2 Dynasty brush and use short, choppy overlapping brushstrokes to paint the shingles. Make sure that the angle of the brush follows the angle of the roof.

Use a no. 4 sable script to paint additional cracks. You can add a small amount of gingerbread detail on the posts and corner of the roof. Drybrush a little more highlight on the side of the house. Cast shadows under the overhangs will add depth to the roof line. Just have fun with it.

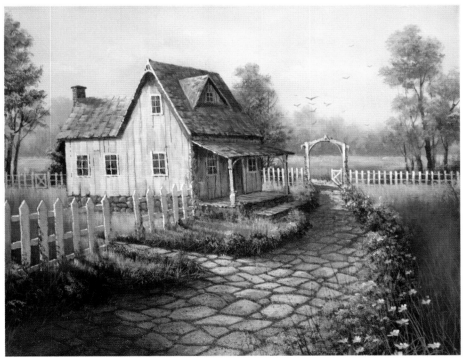

17 Add Flowers and Final Details

Create a creamy mix of equal parts Dioxazine Purple and white. Load the tip of a no. 4 bristle flat and very lightly dab in some purple flowers along the pathway. Then lighten the mix substantially and highlight the flowers. Continue this process using any colors you wish until you have all the flowers you desire.

Use a no. 4 sable round to paint some green leaves or vines growing up the porch-post or corner of the house. Switch to a no. 4 sable script to paint in some taller weeds in the corners. Finish by adding a few birds in the sky.

Paint a Bridge & Babbling Brook

PEDESTRIAN CROSSING

There is nothing more relaxing than taking a walk on a late Spring morning as the sun begins to filter its light through the canopy of new leaves and the dew drops come alive, sparkling like diamonds in the sunlight. As you follow the dirt pathway along the babbling brook, you come to a crossing—an old wooden footbridge. The weathered wood arches gracefully across the gentle moving water. As you take the first step you cannot help but wonder how many others went before you.

As you continue your journey across, your artistic senses get the best of you, and you begin noticing the unique cracks, interesting textures and beautiful colors that truly make this a subject worth spending some of your time and creative skills on.

This may seem like a simple challenge, but don't be fooled. You'll be surprised at all you will learn.

Materials

SURFACE
16" × 20"
(41cm × 51cm)
stretched canvas

ACRYLIC PIGMENTS
Burnt Sienna, Burnt Umber, Cadmium Orange, Cadmium Yellow Light, Dioxazine Purple, Hooker's Green, Ultramarine Blue, Vivid Lime Green

BRUSHES
- nos. 2, 4, 6 and 12 bristle flats
- no. 4 Dynasty
- no. 4 sable flat
- no. 4 sable round
- no. 4 sable script

OTHER
- medium or firm toothbrush
- soft vine charcoal
- white gesso

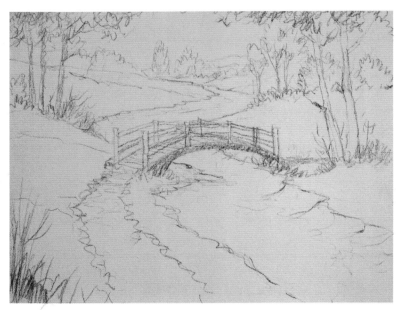

1 Prepare the Canvas and Sketch the Composition

Apply a warm gray tint to the canvas with a no. 12 bristle flat. Once dry, make a rough, simple sketch of the basic components of the painting with soft vine charcoal. Specifically, focus on the location and proportion of the bridge and the contour of the land masses and pathway. You will lose most of the sketch as you paint, so don't spend a lot of time on details.

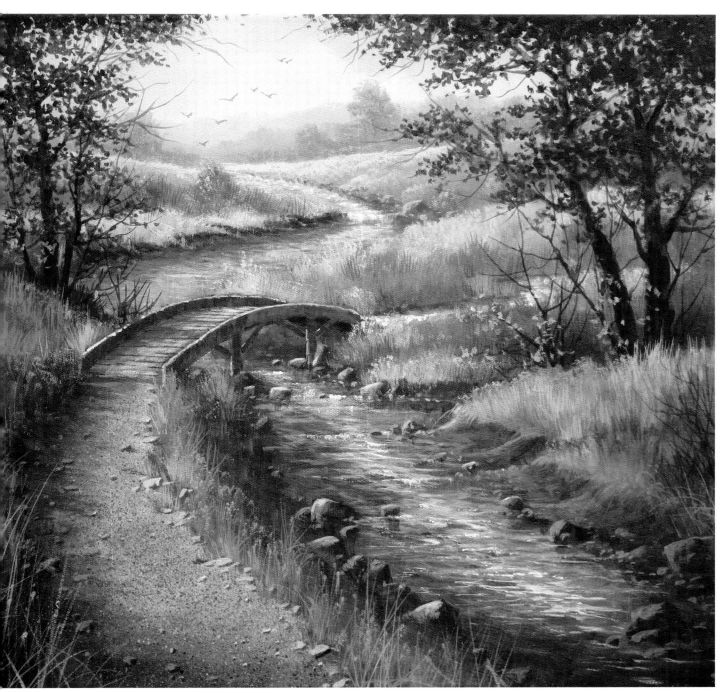

Pedestrian Crossing
Acrylic on canvas
16" × 20" (41cm × 51cm)

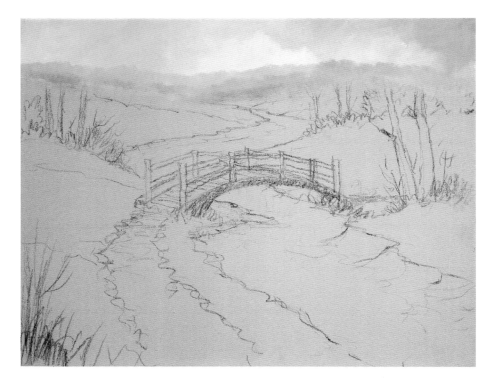

2 Underpaint the Sky and Distant Hills

Load a no. 6 bristle flat with white and begin scrubbing into the right-hand corner of the composition. As you proceed across the canvas, add touches of Dioxazine Purple and Ultramarine Blue to create a soft mauvish tint. Gradually lighten the tint as you work your way left.

While the sky is still wet, add a small amount of Dioxazine Purple to the mauvish tint to darken it slightly. Scrub in the first layer of distant hills. Then add a touch of Hooker's Green to the mixture to create a mauvish-green tint. Paint in the next layer and value of hills.

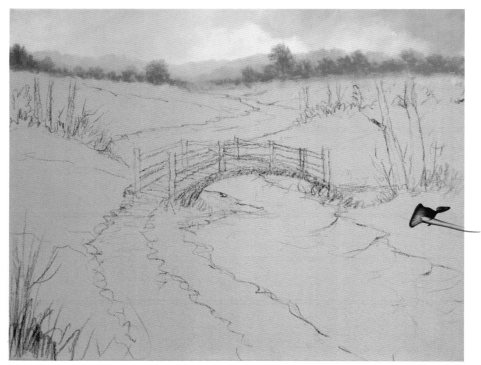

3 Paint the Trees

Mix Hooker's Green with a touch of Dioxazine Purple and just enough white to create a greenish tone that is about two values darker than the last layer of hills you painted. Carefully paint in the taller trees with a no. 2 bristle flat. Keep them soft and create different shapes and sizes with interesting pockets of negative space all along the horizon area.

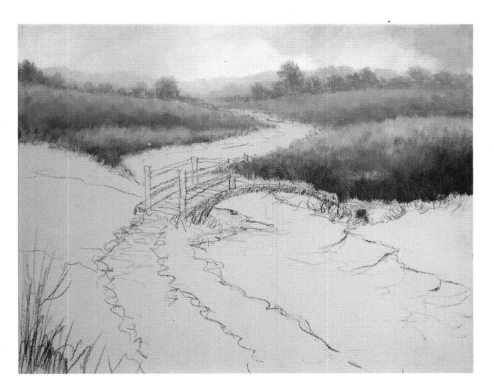

4 Underpaint the Distant Meadow

Mix Cadmium Yellow Light with a touch of Hooker's Green to create a rich yellow-green. Double-load a no. 6 bristle flat and begin scrubbing short vertical, choppy brushstrokes into the meadow area. As you go along, you can add touches of Cadmium Orange or Burnt Sienna to warm it up and add touches of Dioxazine Purple and more Hooker's Green to darken it. Try to get a good variety.

cad yellow lite
Hookers green
cad orange
Burnt sienna
Dio' Purple

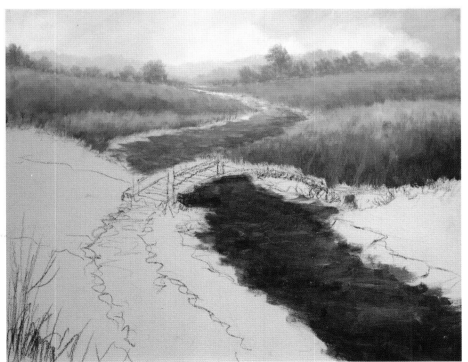

5 Underpaint the Water

Mix white and Ultramarine Blue with touches of Dioxazine Purple and Burnt Sienna. Underpaint the water with a no. 4 bristle flat. Mottle the colors together as you go, using short, choppy overlapping horizontal brushstrokes.

Keep in mind that this is only underpainting, so the water needs to be dark at this stage. You will be adding two or three layers of highlights in future steps.

Blue
Purple
Sienna

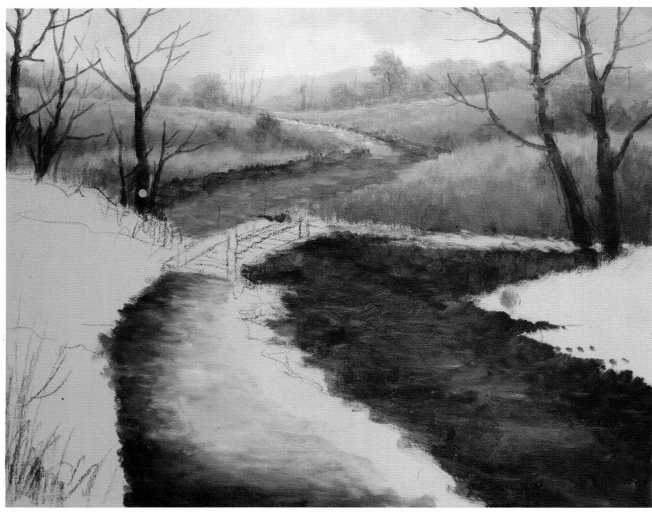

Burnt
Umber
Ultramarine
white

6 Continue Building Up the Background and Middle Ground, Block In the Tees and Pathway

Mix Burnt Umber with a touch of Ultramarine Blue and just enough white to create a medium dark warm gray tone that is slightly on the brown side. Scrub in this color along the distant shoreline with a no. 4 bristle flat. Leave the edges soft and smudgy. Add a little Burnt Sienna to the mixture and underpaint the eroded river bank on the lower-right side of the composition using comma-like brushstrokes. You can add touches of white as you go along to highlight the ridges that separate the sections of river bank.

Load a small amount of Hooker's Green and Burnt Umber onto a no. 4 bristle flat and block in the bushes behind the meadow ridges. Create a medium warm gray tone by mixing Ultramarine Blue and Burnt Sienna with a touch of white. Smudge in the rough shapes of tree trunks and bare tree limbs in the middle ground with a no. 4 sable flat. Keep them soft. Finish out the intermediate and smaller limbs with a no. 4 sable round. Be sure to create interesting pockets of negative space. Mix Vivid Lime Green with a touch of white and dab highlights onto the distant trees with a no. 2 bristle flat. Use the same brush and paint mixture to highlight the top of the meadow ridges.

Mix white with a small amount of Burnt Umber and a touch of Dioxazine Purple to create a soft, warm dirt color. Use a no. 4 bristle flat to begin painting in the base of the pathway using short, choppy horizontal brushstrokes. As you work your way forward, add more Burnt Umber and Dioxazine Purple to gradually darken the path. You'll also want to be sure to darken the left side, which is in shadow. It's okay to leave the pathway a little rough with brushstrokes showing.

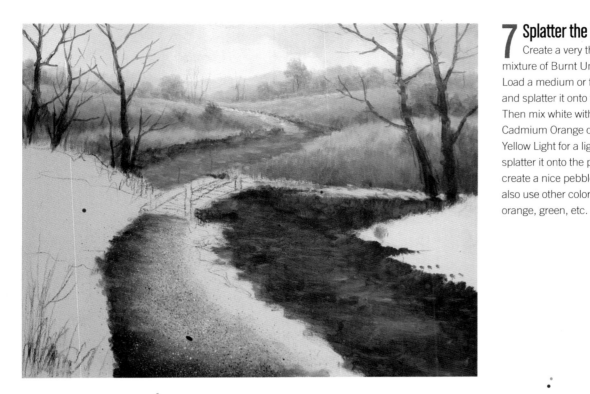

7 Splatter the Pathway

Create a very thin dark-value mixture of Burnt Umber and water. Load a medium or firm toothbrush and splatter it onto the pathway. Then mix white with a touch of Cadmium Orange or Cadmium Yellow Light for a lighter value and splatter it onto the pathway. This will create a nice pebble effect. You can also use other colors like red, blue, orange, green, etc.

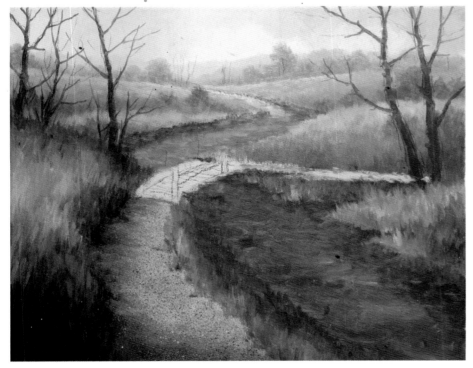

8 Build Up the Foreground Grasses

Mix Hooker's Green with a touch of Burnt Sienna or Cadmium Orange and use a no. 6 bristle flat to scrub in a variety of vertical brushstrokes that suggest tall grasses and brush. You can add Cadmium Yellow Light or Vivid Lime Green for lighter, more spring-like areas. Use Dioxazine Purple or Burnt Umber for the darker shadow areas.

The key is to create a good variety of contrasting values as well as tonal values. Keep in mind that these meadows are closer in the foreground, so your brushstrokes can be taller, looser and more textured here.

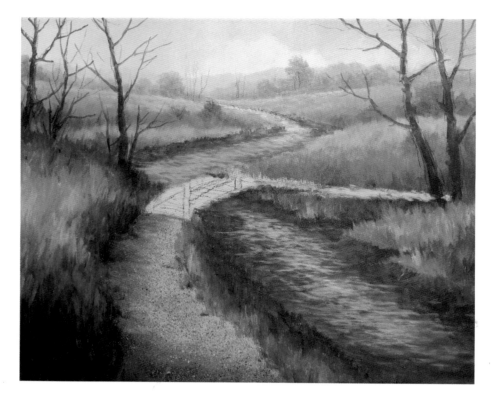

9 Highlight the Water

Mix white with a touch of Ultramarine Blue and thin it to a creamy consistency. Use a no. 2 or no. 4 bristle flat and short, choppy horizontal brushstrokes to begin painting ripples in the water. Focus on the center of the stream and gradually fade toward the edges. This is only the first phase; you will apply the final highlights later.

Ultramarine Blue
touch white

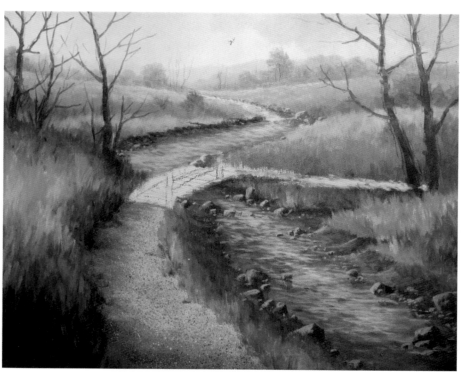

10 Paint the Rocks

The goal here is to create a variety of small rocks scattered along the shoreline. Begin by taking the mixture you used in Step 6 for the shoreline and add a little Ultramarine Blue to darken it slightly. Block in rock shapes along the shoreline with a no. 4 sable flat. Add touches of white and Cadmium Orange to the mixture to lighten it, and then highlight the rocks.

Burnt umber
Ultramarine Blue
white /mix to grey on
Brown side

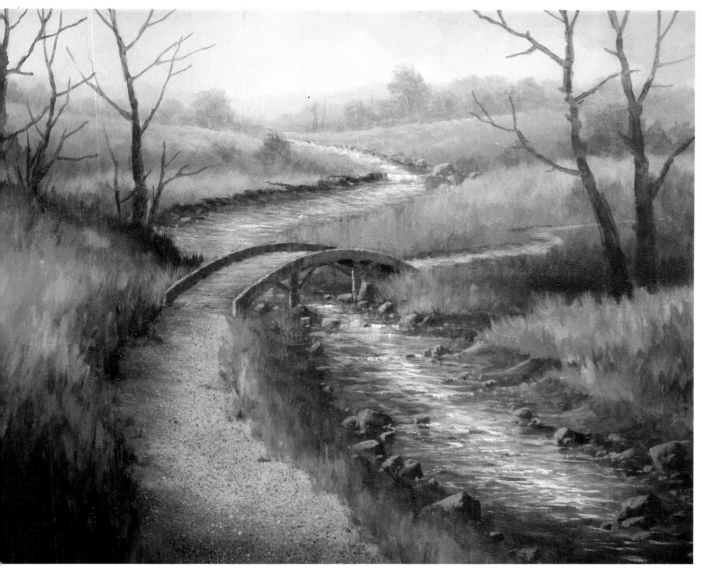
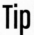

11 Block In the Footbridge

Use soft vine charcoal to sketch in the shape of the bridge in more detail. Make sure it is properly proportioned to the stream. Don't be fooled by the seemingly simple shape of this bridge. The aspects of angle, arch, foreshortening and location are more challenging than they seem. For instance, you may need to rearrange the angle of the pathway to better fit with the bridge angle. Just take your time to work through these things until you are happy. Then use any of your smaller brushes to block in the bridge using a medium gray mixture of Ultramarine Blue, Burnt Umber and white. Add more white with a touch of Cadmium Orange for the lighter areas.

Tip If you happen to over-highlight any area of your painting, simply desaturate the highlights and begin again. There is no shame in starting over— several times, if necessary. We all have to do it from time to time.

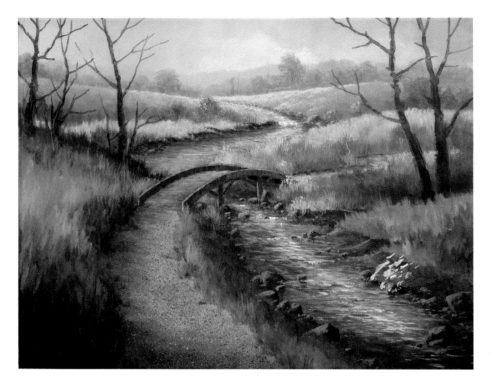

12 Add Highlights

Use a no. 4 bristle flat and a no. 4 Dynasty brush to highlight the background and middle-ground meadows, as well as create more interesting shapes in the brush and clumps of weeds.

I recommend using a bristle brush for dabbing on textured colors of various light tones. Use the Dynasty brush for pulling up grasses along the edge of the river and pathway and to seat the bridge.

Tones that work best for highlights are Vivid Lime Green with a touch of white or Cadmium Yellow Light with a touch of white. Just experiment with a variety of light greens until you get the effect you desire.

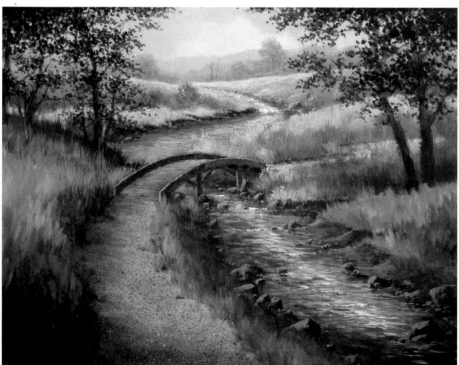

13 Paint the Canopy Leaves

Create a creamy base mixture of 3 parts Hooker's Green and 1 part Dioxazine Purple with a small amount of Burnt Sienna. Make a large amount so that you won't have to keep re-mixing. Load the tip of a no. 6 bristle flat and gently begin dabbing a canopy of leaves onto the trees. Make sure that you leave interesting pockets of negative space in, around and through the canopy to create good eye-flow. It's okay if the paint is somewhat textured—this actually adds a nice effect to the leaf pattern.

3 Paul Hookees green
1 port Penuppe
touch Burnt seena

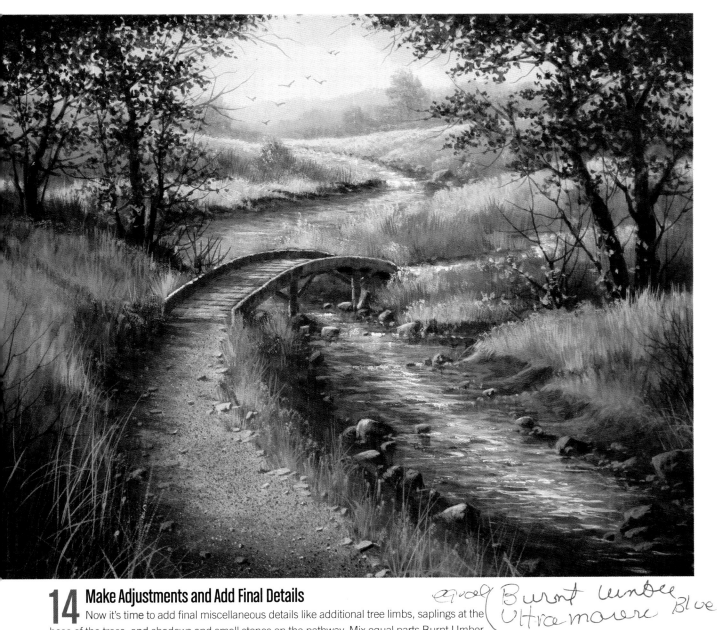

14 Make Adjustments and Add Final Details

Now it's time to add final miscellaneous details like additional tree limbs, saplings at the base of the trees, and shadows and small stones on the pathway. Mix equal parts Burnt Umber and Ultramarine Blue. Thin it to an ink-like consistency and paint in the tree limbs and saplings with a no. 4 sable script.

Mix 3 parts Ultramarine Blue with 1 part Burnt Sienna and a touch of white. Then add a small amount of Dioxazine Purple to create a soft mauvish-gray tone. Smudge in some cast shadows along the left edge of the pathway with a no. 4 sable round. Then add some small rocks along the edge of the path.

Now use your artistic license and have fun finishing up whatever details and additions you desire. For instance, you could dab on a few soft flowers along the path and foreground grasses, plus taller contrasting weeds. Or you may choose to add brighter highlights on the bridge and pathway. And of course, a few birds flying in the sky is always a nice touch. The most important thing is to not over-detail your work or make the painting too busy.

equal Burnt Umber
Ultramarine Blue

3 part Ultramarine
1 part Burnt Sienna
touch white

Paint a Quaint Farm

FARMER'S PARADISE

When I first began my art career in the late 70s, it seemed like every artist I knew used barns and old buildings as their main subject matter. Most subjects seem to trend in cycles in the art world, but there is something about a charming, iconic old barn that stands the test of time. Although many of them are beginning to decay and fall apart, they are still high on my list (as with many other artists) as a great subject to paint.

Let the unique perspected angles, shapes and colors of these beautiful structures set against a summertime landscape inspire you. The green rolling hills and pastures dotted with cattle will take you back to a much simpler, more peaceful time.

Materials

SURFACE
16" × 20"
(41cm × 51cm)
stretched canvas

ACRYLIC PIGMENTS
Burnt Sienna, Burnt Umber, Cadmium Orange, Cadmium Red Light, Cadmium Yellow Light, Dioxazine Purple, Hooker's Green, Ultramarine Blue, Vivid Lime Green

BRUSHES
- nos. 4, 6, 10 and 12 bristle flats
- nos. 2, 4 and 6 Dynasty
- no. 4 sable flat
- no. 4 sable round
- no. 4 sable script

OTHER
- medium or firm toothbrush
- soft vine charcoal
- white gesso

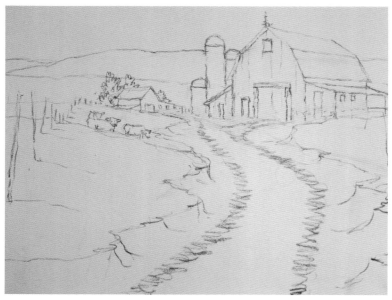

1 Prepare the Canvas and Sketch the Composition

Apply a warm gray tint to the canvas with a no. 12 bristle flat. Let it dry. Use soft vine charcoal to roughly sketch in the basic contours of a farm landscape, including a barn and other buildings. Do not make the sketch too detailed. After you do some of the underpainting, you can make a more accurate sketch to work out the perspective of the buildings if necessary.

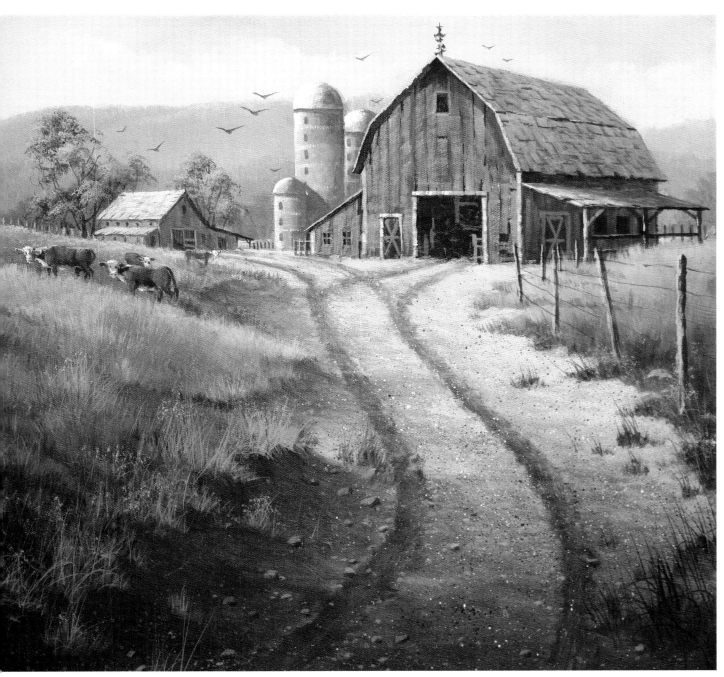

Farmer's Paradise
Acrylic on canvas
16" × 20" (41cm × 51cm)

Tip Do not use pencil or any other type of hard graphite or charcoal for sketching your composition—they are very difficult to erase.

To erase soft vine charcoal lines or smudges, simply brush gently with a damp paper towel. Any marks will be removed easily.

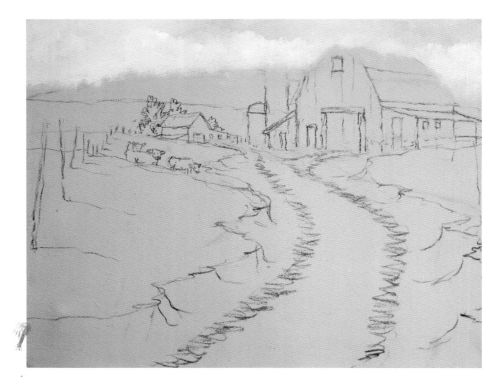

2 Paint the Sky

Mix 3 parts white with 1 part Ultramarine Blue and a touch of Dioxazine Purple to get a medium-light value. Load a no. 10 or no. 12 bristle flat and paint in the sky using short, overlapping crisscross brushstrokes. Add small amounts of white to scumble in the suggestion of soft, wispy clouds. Keep the sky simple and fairly light.

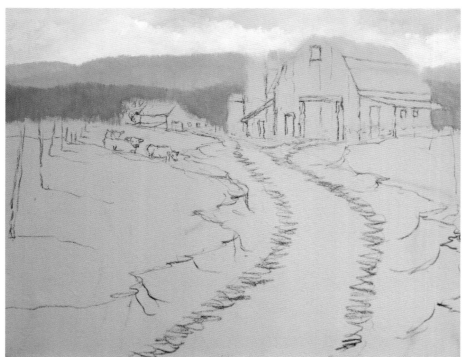

3 Underpaint the Background Hills

There will be three values for this step: Value 1 is the closest range of shorter hills; Value 2 is the hills in the middle; and Value 3 is the most distant hills behind the barn. Create a base mixture of white with touches of Hooker's Green and Dioxazine Purple to get a soft grayish green. Mix the proper value for the first hill and block it in with a no. 6 bristle flat. Follow the same process for the next two values and ranges of hills. Use short, choppy vertical brush-strokes and make sure each hill has soft edges.

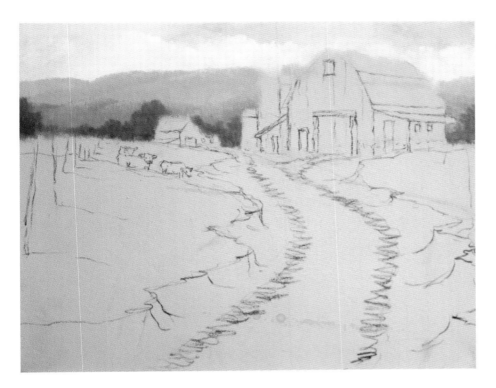

4 Highlight the Hills and Paint the Trees

Mix white with a touch of Vivid Lime Green. Load a small amount onto the tip of a no. 4 bristle flat and gently dab the highlight along the top of the hills and down the left side to create valleys and ridges.

Add a little Hooker's Green and Dioxazine Purple to the mixture to create a grayish green. Paint in the trees behind the building at the base of hills.

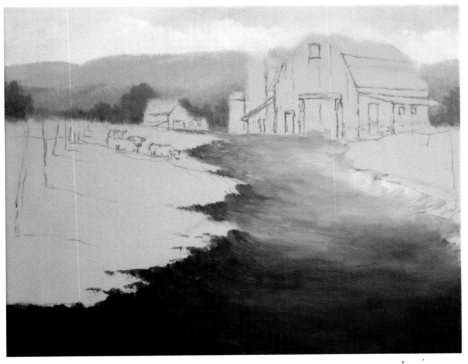

5 Underpaint the Road

Mix equal parts white and Burnt Umber. Load a little of this base mixture along with a bit of Burnt Umber and a touch of Dioxazine Purple onto a no. 6 bristle flat. Beginning on the left side of the dirt road, block in the banks using short, comma-like brushstrokes. Flatten out the brushstrokes as you get into the middle of the road. Begin blending across and downward, gradually making the road darker as you come forward.

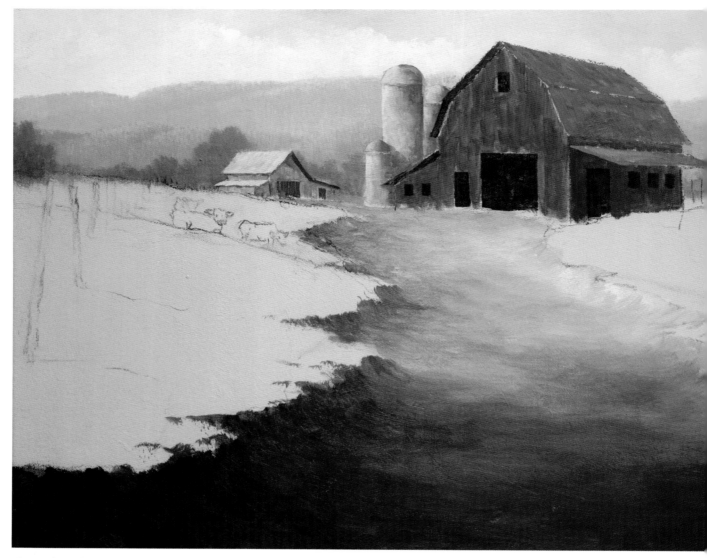

6 Underpaint the Buildings

Take your soft vine charcoal and re-sketch the barn and other buildings more accurately. There is no need to go overboard with details—do just enough to make sure the perspective, proportions and shapes are what you want.

Mix white with touches of Burnt Umber and Ultramarine Blue to get a medium-light warm gray. Use a no. 2 Dynasty brush to block in the shadowed side of the silos and the small building, then add more white with a touch of Cadmium Orange to paint in the non-shadowed sides. Add more Ultramarine Blue and Burnt Umber to darken the mixture for the doors and windows. You will apply final details and highlights in a later step. Just remember the

sun is coming in from the left side, and your values should be in the medium range.

Since the barn is old and weathered, the underpainting will be a reddish-gray. Mix Cadmium Red Light with touches of Dioxazine Purple and Ultramarine Blue. Then add a small amount of white to make it opaque. Paint in the front of the barn with a no. 4 Dynasty brush. Continue using the same brush to paint the side of the barn, but darken the mixture with a little more Ultramarine Blue. Use an equal mix of Burnt Umber and Ultramarine Blue for the doors and windows. For the roof, take the same mixture you used for the doors and windows and add white to create a medium gray.

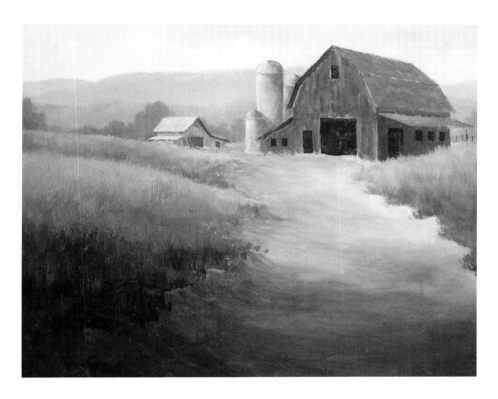

7 Underpaint the Meadow

Mix Cadmium Yellow Light with touches of Hooker's Green and Cadmium Orange. Triple-load a no. 4 or no. 6 bristle flat and scrub horizontally across the meadow area, gradually darkening it as you come forward.

Wipe out your brush and hold the tip horizontal to the canvas. Start at the top of the meadow and gently push upward with the tip of the brush. Continue working your way down through the meadow, letting each row overlap the other. Keep the paint thick to create a little texture, which makes the grass look more natural.

As you layer the colors, they should get darker as you move into the foreground. To get the darker foreground hues, just add a little Dioxazine Purple to Hooker's Green. Be sure to keep the very dark tones confined to the lower left corner.

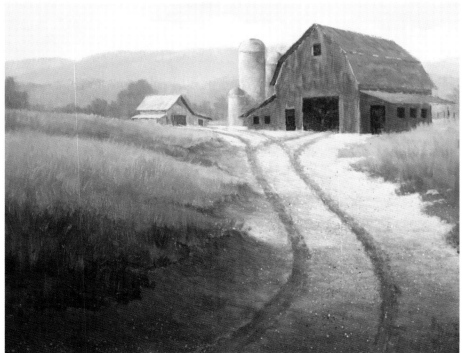

8 Add Ruts in the Road

Mix 3 parts Burnt Umber with 1 part white. Load a no. 4 bristle flat and paint short, overlapping concave brushstrokes to create ruts in the road. Make them smaller, lighter in value and closer together as they recede into the distance. As they come forward, they should get larger, darker and further apart. You want them to look a little rough, so don't smooth them out too much. Keep the edges a bit irregular.

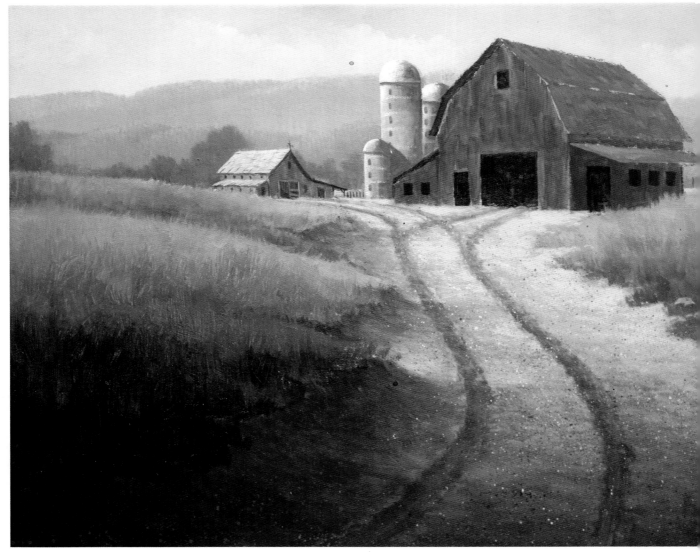

9 Detail the Road, Silos and Small Building

Mix white with a touch of Cadmium Orange. Use a no. 4 bristle flat to rough up the road a little bit and make it appear more like dirt. Allow some of the underpainting to show through. Then use a medium or firm toothbrush to splatter multiple colors of light and dark values throughout the road to suggest pebbles and small rocks.

Begin detailing the small building and silos. This is mostly a matter of adding highlights and shadows, and correcting any perspective or proportional issues. I recommend switching between a no. 4 sable round, a no. 4 sable flat and a no. 2 Dynasty brush for this part of the process. Just use whichever brush works best for each section.

Mix white with Cadmium Orange to brighten the sunlit side of the structures. Add a touch of white to Cadmium Red Light for the red tones. For the doors and windows, mix equal parts Burnt Umber and Ultramarine Blue. You may add whatever details you want at this point—just be sure you get good strong light and shadows.

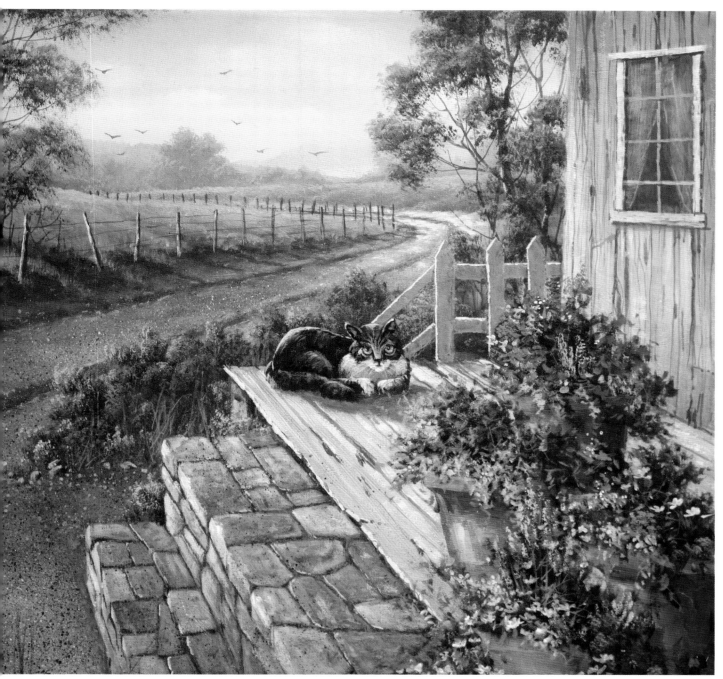

Catnap
Acrylic on canvas
16" × 20" (41cm × 51cm)

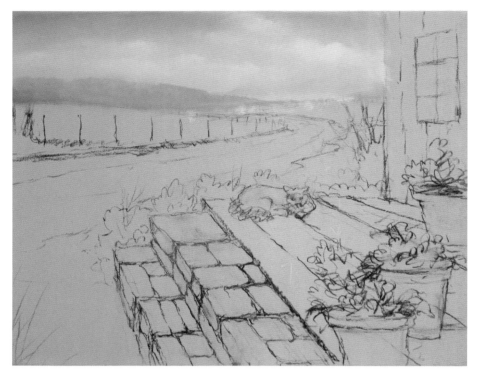

2 Paint the Sky and Distant Hills

Apply a liberal coat of white to the sky area with a 2" hake brush. While still wet, add Cadmium Red Light across the horizon and blend half-way up. Then mix Ultramarine Blue with a touch of Dioxazine Purple and paint across the top of the sky, blending downward to create a soft gradation of color.

Mix white with touches of Ultramarine Blue, Burnt Sienna and Dioxazine Purple to get a soft mauvish-gray tone. This should be about two values darker than the sky. Load a no. 4 bristle flat and paint in the first layer of hills. Then darken the mixture a little for the second layer.

Tint a small amount of white with a touch of Cadmium Orange. Carefully scrub in some soft, simple clouds.

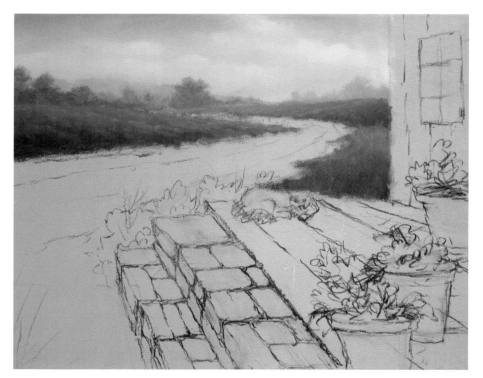

3 Underpaint the Meadow and Distant Trees

Mix Hooker's Green with a touch of Dioxazine Purple to create a soft grayish-green tone. Then add just enough white to make it about two values darker than the distant hills. Use a no. 2 or 4 bristle flat to dab in the shape of the distant trees scattered along the base of the hills. Darken the paint mixture by adding a little more Hooker's Green and a touch of Dioxazine Purple. Scrub this color on the distant meadows with a no. 6 bristle flat. As you go along, add touches of Cadmium Yellow Light, Cadmium Orange and white to create a variety of soft values of warm greens. Do not over-blend it.

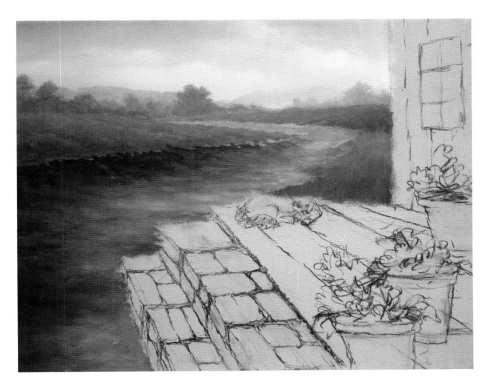

4 Underpaint the Road

Mix white with a touch of Burnt Umber. Use a no. 6 bristle flat to begin painting the road with short choppy, horizontal strokes. Start at the back and work your way forward. As you go along, begin adding more brown and touches of Ultramarine Blue and Dioxazine Purple to gradually darken the value. Continue making the road darker as you move into the foreground next to the steps.

Make sure the left side of the road is darker than the right side. If you need to lighten up the right side of the road, you can mix white with touches of Cadmium Orange. Apply the paint fairly thick in order to cover the canvas well and create a bit of texture. Do not be afraid to leave brushstrokes showing.

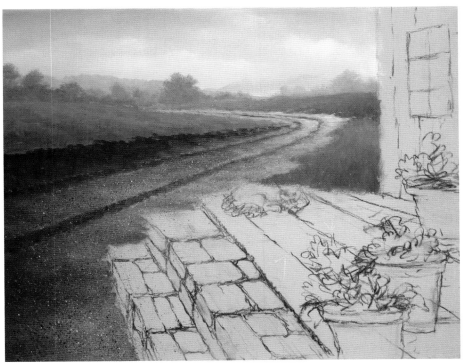

5 Continue Building Up the Road

Load a small amount of Burnt Umber on the tip of a no. 4 bristle flat and lightly drag and drybrush in the shape of ruts in the road using long brushstrokes. Make the ruts wider and farther apart in the foreground, and narrower and closer together as they recede into the background. Be careful not to make them too dark—they should get lighter as they recede.

Use a medium or firm toothbrush to splatter multiple dark and light colors on the road, especially in the foreground and middle ground.

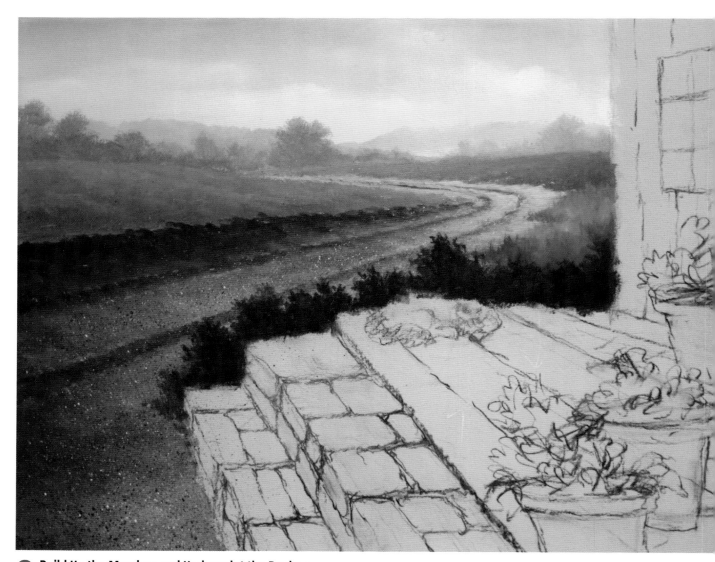

6 Build Up the Meadow and Underpaint the Bushes

Mix Hooker's Green with touches of Cadmium Orange and Cadmium Yellow Light. Use a no. 6 bristle flat and short choppy vertical brushstrokes to build up the meadow grasses behind the porch on the right side of the road. Make sure this is fairly bright to create the effect of sunlight. It is also okay for this area to be a little textured.

Mix Hooker's Green with touches of Dioxazine Purple and Burnt Sienna. Use a no. 4 or no. 6 bristle flat to dab in the basic shape of the bushes. Make sure these have interesting pockets of negative space and are not lined up in a row.

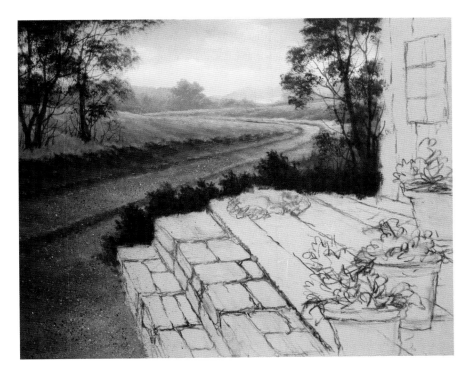

7 Highlight the Meadow and Background Trees, Block In the Foreground Trees

Mix white with a touch of Hooker's Green, Cadmium Orange and Cadmium Yellow Light to get a soft, light olive-green tone. Gently dab highlights onto the background trees with a no. 2 bristle flat.

Add more Cadmium Yellow Light and Cadmium Orange to the mixture and scrub highlights on the meadow grasses using short, choppy horizontal brush-strokes. You can add more or less white or Cadmium Yellow Light to get the exact highlight you want.

For the foreground trees, create a medium charcoal gray tone by mixing Ultramarine Blue with touches of Burnt Umber and white. Thin it to an ink-like consistency. Block in the tree trunks and basic shape of the leaf canopies with a no. 4 sable script.

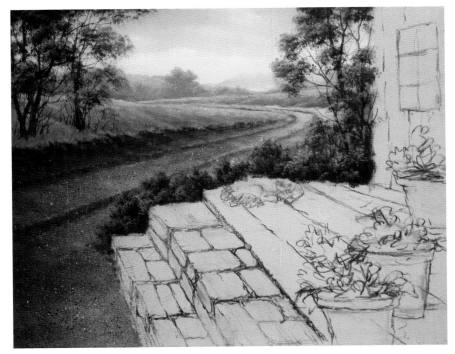

8 Continue Developing the Foreground Trees

Mix Hooker's Green with touches of Burnt Sienna and Dioxazine Purple. Make sure it is a creamy consistency and a medium-dark value. Load a no. 6 bristle flat and dab leaves on the trees. Create interesting pockets of negative space and leave sky holes so that you can see in, around and through the canopy. Keep the edges of the canopy soft. This is more of a drybrush stroke, which will help with the soft edges.

Mix Hooker's Green with touches of Cadmium Orange and Cadmium Yellow Light to get a soft light olive-green tone. Load a no. 4 or no. 6 bristle flat and dab highlights on the top-left area of each clump of leaves to create good dimensional form and sunlight. For the final highlights, add more white and Cadmium Yellow Light to the mixture, then carefully accent the edge of each clump.

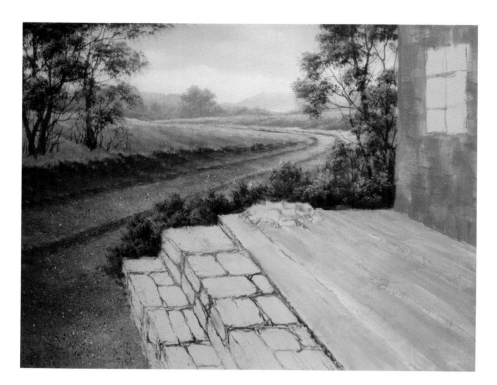

9 Underpaint the Porch

Mix 3 parts Ultramarine Blue with 1 part Burnt Sienna, plus a touch of Dioxazine Purple and just enough white to create a creamy medium-dark gray tone. Use a no. 10 bristle flat or a no. 10 Dynasty brush to underpaint the front of the building with long, vertical brush-strokes. Be sure to cover the canvas well. Then lighten the mixture slightly and underpaint the porch floorboards.

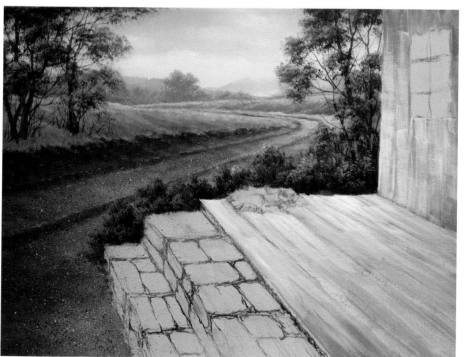

10 Add Weathered Wood Effects

Take a small amount of the mixture from the previous step, lighten it slightly with white, then add a touch of Cadmium Orange. Thin it to a glaze and load a small amount onto a no. 10 Dynasty brush. Gently and lightly skim the surface of the building and floorboards, creating the look of rough weathered wood. Lighten the mixture and repeat the skimming process two or three more times until you achieve the level of brightness you desire.

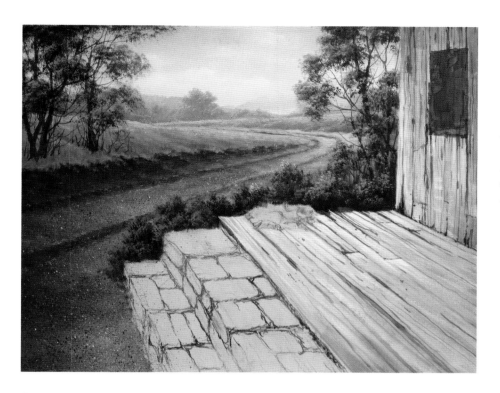

11 Paint the Window and Detail the Wood

Create a dark mixture from equal parts Ultramarine Blue and Burnt Umber. Use a no. 6 Dynasty brush to paint in the large window. Then thin the mixture to an ink-like consistency and create details like cracks, holes and crevasses in the wood with a no. 4 sable script. Have fun using your artistic license, but be careful—it's easy to overdo it.

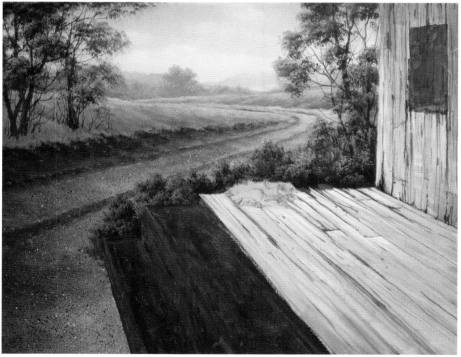

12 Underpaint the Stone Steps

Mix 3 parts Burnt Umber and 1 part Ultramarine Blue with touches of Dioxazine Purple and white to get a warm charcoal gray tone. Block in the side of the steps with a no. 6 bristle flat. Then lighten the mixture slightly and underpaint the top of the steps. Do not be afraid to put the paint on fairly thick and to leave your brushstrokes showing.

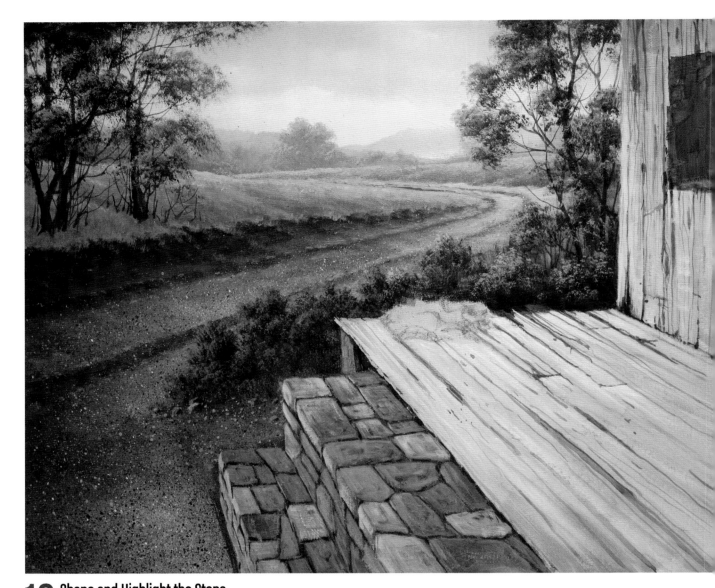

13 Shape and Highlight the Steps

Use a white Contè pencil to re-sketch the shape of the stones on the steps. You may have noticed that I re-shaped these stones differently from the original sketch. Don't be afraid to use your artistic license and make changes as you go along.

Take a small amount of the underpainting color you used in the previous step and add small amounts of white and Cadmium Orange. Thin it to a glaze-like consistency. Paint in the basic shapes of the stones on the side of the steps with a no. 4 bristle flat or no. 4 Dynasty brush. Then slightly lighten the mixture by about two values and paint in the capstones on top of the steps. Repeat this step a couple of times until you have the level of brightness you desire.

You may also have noticed that I made the steps a little shorter here. I thought it looked more appealing, however, this is purely optional. If you choose to do this, just paint some dirt and bushes in behind the stairs to match what you did in earlier steps.

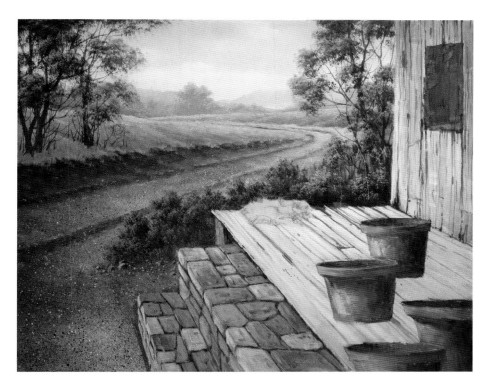

14 Underpaint the Flower Pots

Sketch in the basic shapes of flower pots with soft vine charcoal. Then mix Burnt Sienna with a touch of Dioxazine Purple to slightly darken it. Use a no. 4 bristle flat to apply this color to the right side of the pots and blend across. As you go, begin adding more Burnt Sienna and touches of Cadmium Orange to create a rich terra-cotta color. Make sure you end up with three values so that the pots appear three dimensional.

Even though the foliage will end up covering most of the top of the pots, go ahead and paint the insides by reversing the value system.

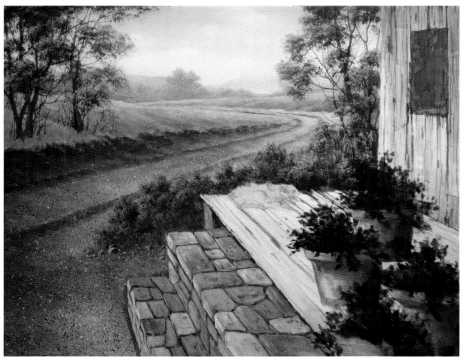

15 Add the Flower Foliage

Create a creamy dark green mixture of 3 parts Hooker's Green and 1 part Dioxazine Purple. Use a no. 4 bristle flat to scumble a nice arrangement of foliage in the flower pots. Make sure you fill up the area with irregular pockets of negative space. As you shape the outer edges, switch to a no. 4 sable round or a no. 2 Dynasty brush and scumble the suggestion of leaves. Highlights will come later.

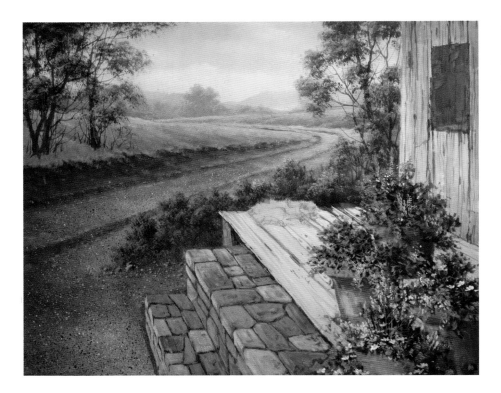

16 Paint the Flowers

Take dark values of Cadmium Red Light, Cadmium Orange, Cadmium Yellow Light, Dioxazine Purple and Ultramarine Blue and begin dabbing or scumbling in various shapes, sizes and textures to suggest flowers. Have fun experimenting with different brushstrokes and levels of pressure to create different effects. Use any of your small bristle flats for this. However, if you prefer to paint more detailed flowers with individual petals and leaves, use a no. 2 Dynasty brush. Add a little white to the original mixture for minor highlights. You will add final highlights as needed in the last step.

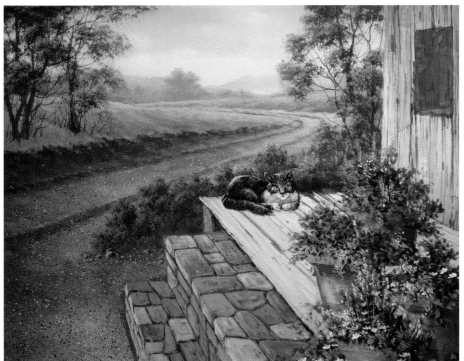

17 Paint the Cat

This will be a black-and-white cat. For the black, mix equal parts Burnt Umber and Ultramarine Blue with a touch of Dioxazine Purple. Use a no. 2 bristle flat to completely cover the black areas of the cat's body.

Then take some of the black mixture and add just enough white to create a medium gray. Block this in on the cat's chest and parts of his face. You may need to use smaller brushes like a no. 4 sable round or no. 4 sable flat for some of the smaller areas. You will highlight the cat in the final step.

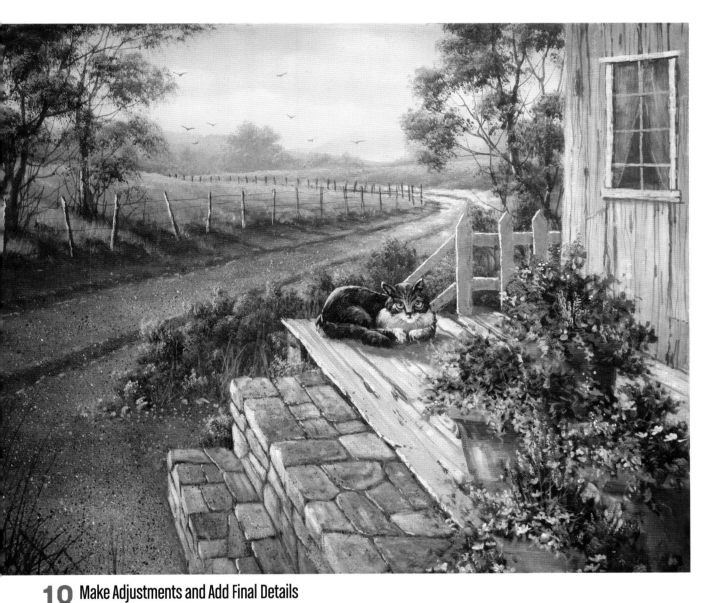

18 Make Adjustments and Add Final Details

Mix a medium charcoal gray tone and paint in the fence posts with a no. 4 sable round. Make the posts gradually lighter as they recede into the distance. Then add touches of Hooker's Green and Dioxazine Purple to the mixture and scrub in the tree's cast shadow with a no. 2 bristle flat. Do the same thing for the fence-post cast shadows.

Use a no. 4 Dynasty brush and any color you like to drybrush curtains in the window. Then paint the window panes in a medium-light gray tone using a no. 4 sable round. Create an ink-like mixture of equal parts Hooker's Green and Dioxazine Purple. Switch to a no. 4 sable script and paint the tall weeds in the lower-left corner.

Mix Cadmium Yellow Light with touches of Turquoise Deep and white to create a vivid green. Highlight the foliage with a no. 2 Dynasty brush. For the flowers, just add a touch of white to the original color and use the brush of your choice to dab, scumble or paint on highlights. To highlight the pots, mix Cadmium Orange with a touch of white.

Use a no. 4 sable round and a no. 4 sable flat to highlight the cat. For the black areas, take the black mixture you created in the previous step and add a touch of white. For the white areas, and a touch of Cadmium Orange to some white to create a warm white highlight.

Mix Ultramarine Blue with touches of Burnt Sienna, Dioxazine Purple and white to get a soft mauvish-gray tone. Scrub in the shadow from the cat and the pots with a no. 2 bristle flat. Make sure the shadows are soft and not too dark.

Now scan the painting. Add additional highlights where you feel they are needed, and look for anything else you want to add, change or remove. Don't forget to add some distant birds.

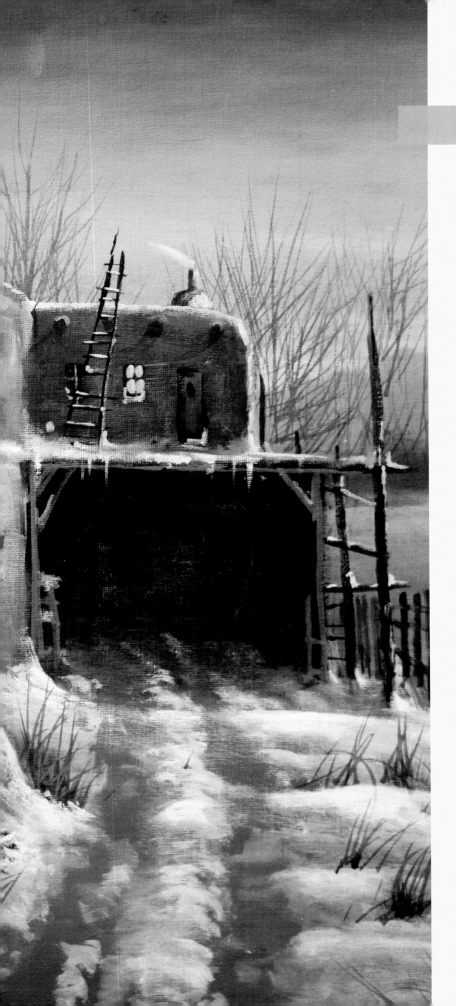

Autumn & Winter

Autumn and winter atmospheres create a great opportunity for artists to explore and fully engage each of their artistic desires.

In the painting demonstrations that follow, you will find multiple subjects—both man-made and natural—that blend together to inspire and motivate your innermost creative thoughts. Whether it be winter waves crashing against massive rock formations or a tranquil stream running through an autumn mountain valley, this chapter will certainly challenge you.

Get ready to take full advantage of your artistic license. Good luck and have fun!

Adobe Sunrise
Acrylic on canvas
18" × 24" (46cm × 61cm)

Paint a Mountain Cabin

GIANTS OF THE HIGH COUNTRY

As an artist and a nature enthusiast, I have always loved the mountains. To wake up to the chill of crisp, fresh mountain air, the sparkle of autumn leaves in the sunlight, the distant sound of elk bugling, the ripple of a cold stream winding its way around giant boulders, and finally, the scent of pine wood smoke coming from a quaint log cabin is nothing short of awe-inspiring. As you stand there soaking it all in, you realize you are nothing more than a speck in the midst of giants: weathered, snow-capped peaks and mountain ridges dotted with the oranges, reds, yellows and golds of Autumn.

Prepare to be inspired. You will smile all the way through this one!

Materials

SURFACE
16" × 20"
(41cm × 51cm)
stretched canvas

ACRYLIC PIGMENTS
Burnt Sienna, Burnt Umber, Cadmium Orange, Cadmium Red Light, Cadmium Yellow Light, Dioxazine Purple, Hooker's Green, Turquoise Deep, Ultramarine Blue, Vivid Lime Green

BRUSHES
- 2" (51mm) hake
- nos. 2, 4, 6 and 10 bristle flats
- nos. 2 and 4 Dynasty
- no. 4 sable flat
- no. 4 sable script

OTHER
- soft vine charcoal
- white gesso

1 Prepare the Canvas and Sketch the Composition

Use a 2" (51mm) hake brush to apply a warm gray tint to the canvas. Once dry, sketch in the main components of the composition with soft vine charcoal. Remember most of the sketch will disappear as you begin painting, so if you aren't sure you can duplicate it later, take a picture or make another sketch to refer to as you proceed with the painting.

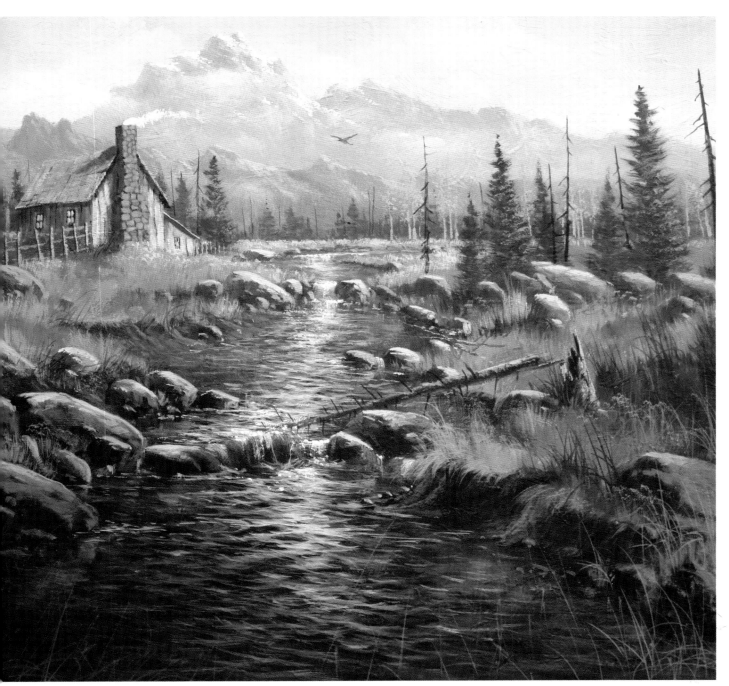

Giants of the High Country
Acrylic on canvas
16" × 20" (41cm × 51cm)

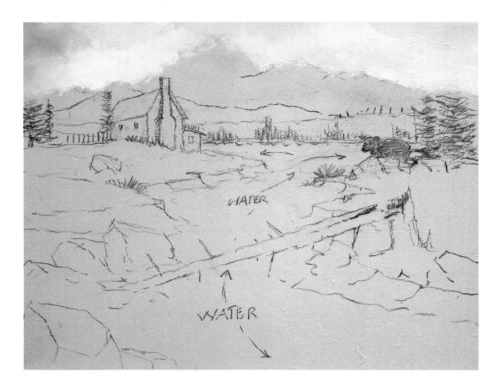

2 Underpaint the Sky

Load a no. 10 bristle flat with white and begin painting across the sky with a scumbling technique. As you go along, add touches of Ultramarine Blue, Dioxazine Purple and Turquoise Deep. Be careful not to make the sky too dark. You want it to be a soft, cool tint. Add a few low-hanging clouds above the mountains.

Since this painting has a lot of subject matter and there will be multiple layers of depth, it is best to keep the sky simple so as not to compete with the main components of the composition.

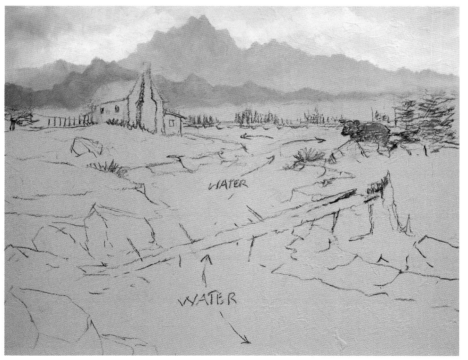

3 Block In the Mountains

Mix white with touches of Burnt Sienna, Ultramarine Blue and Dioxazine Purple to get a medium-light cool gray tone. It's best if the color is slightly on the purple side and only about two values darker than the sky. Block in the most distant mountain range with a no. 4 or no. 6 bristle flat using choppy brushstrokes. Then darken the color by about two values and block in the next range of mountains.

4 Highlight the Mountains

Mix white with a small amount of Cadmium Orange and a slight touch of Ultramarine Blue to get a light, soft warm gray tone. Begin highlighting the mountains with a no. 2 or no. 4 bristle flat using semi-dry, irregular brushstrokes. Make sure you leave a good variety of thick and thin brushstrokes and create interesting pockets of negative space to give the suggestion of cracks and crevices.

The mountain highlights must be completed before you can add the low-hanging clouds and the tree covered ridge at their base.

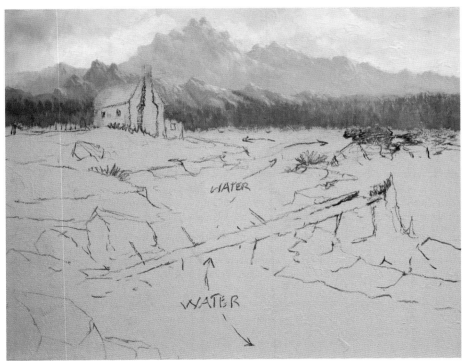

5 Paint the Tree-Covered Ridge

Take the mixture that you created for the mountains in Step 3 and add a little more Dioxazine Purple plus a small amount of Hooker's Green to darken it by about two values. Establish the first greenish tint of pine trees by angling a no. 4 bristle flat vertical to the canvas and painting in the shapes of trees along the ridge and down toward the horizon.

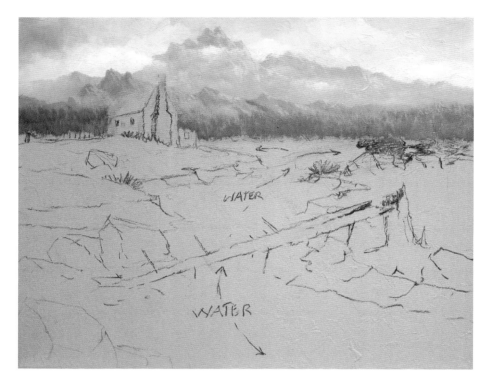

6 Paint the Mist and Low-Hanging Clouds

Mix white with a touch of Cadmium Orange. Be careful not to use too much—this is only a tint, not a color. Load a small amount on the tip of a no. 6 bristle flat and use a drybrush scrubbing technique to paint in the mist and the low-hanging clouds in front of the mountains.

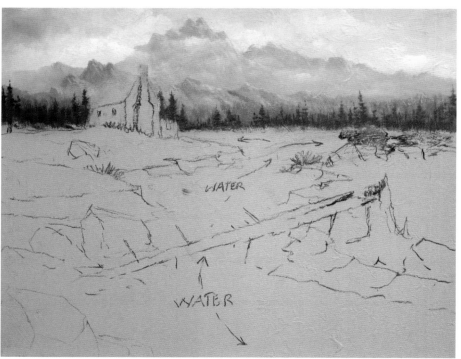

7 Paint the Pine Trees

Mix Hooker's Green with a bit of Dioxazine Purple and just enough white to get a soft mauvish-green color. Make it about two values darker than the color you used for the tree-covered ridge. Paint in an array of tree shapes in various sizes with a no. 2 bristle flat. Don't forget to create interesting groupings and pockets of negative space.

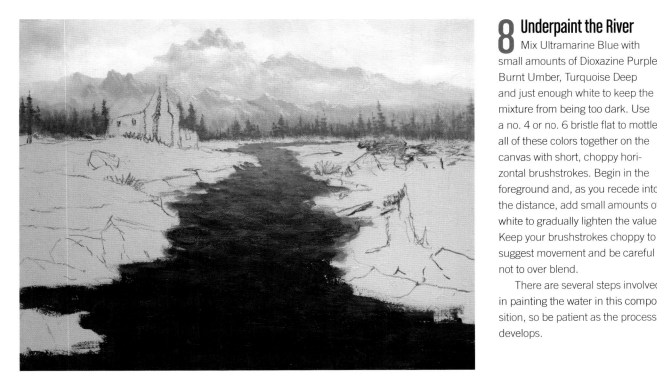

8 Underpaint the River

Mix Ultramarine Blue with small amounts of Dioxazine Purple, Burnt Umber, Turquoise Deep and just enough white to keep the mixture from being too dark. Use a no. 4 or no. 6 bristle flat to mottle all of these colors together on the canvas with short, choppy horizontal brushstrokes. Begin in the foreground and, as you recede into the distance, add small amounts of white to gradually lighten the value. Keep your brushstrokes choppy to suggest movement and be careful not to over blend.

There are several steps involved in painting the water in this composition, so be patient as the process develops.

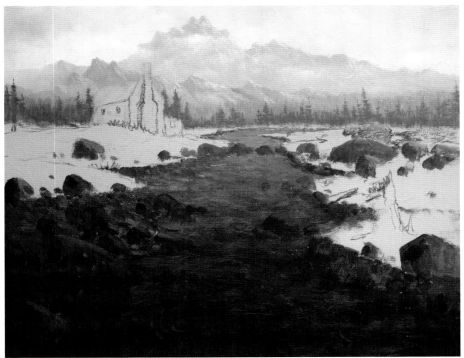

9 Underpaint the River Bank and Rocks

Mix equal parts Ultramarine Blue and Burnt Umber with a touch of Dioxazine Purple. Block in the rocks with a no. 6 bristle flat. Start at the front of the stream and work your way back. Continue adding small amounts of white to the mixture to make minor value changes within each rock and to show distinct shapes and brushstrokes. As you recede into the background, make sure the rocks become slightly lighter in value to create depth.

Use the same brush and color mixture to underpaint the river banks, but add a little Burnt Sienna to warm it up. Make sure the banks on the left side of the river are lighter in tone as that is the sunlit side.

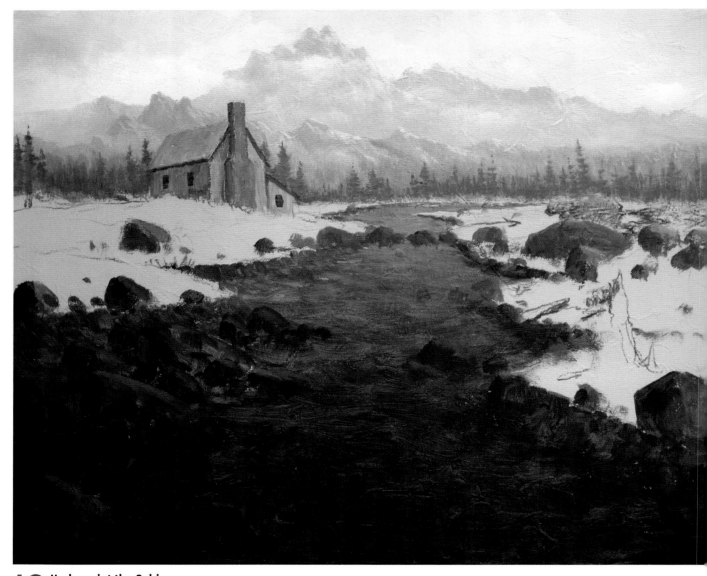

10 Underpaint the Cabin

Use soft vine charcoal to re-sketch the cabin if necessary. Now is the time to make any needed corrections to the perspective, proportions and overall design.

Take the same mixture you used for the rocks in the previous step and add just enough white to change the values. Underpaint the shadowed and sunlit parts of the cabin with a no. 2 or no. 4 Dynasty brush. It is important to make sure the entire cabin is the correct value for its location in the painting. Refer to the grayscale in Chapter 2 if needed.

Tip Nature is your best teacher—study it with intensity.

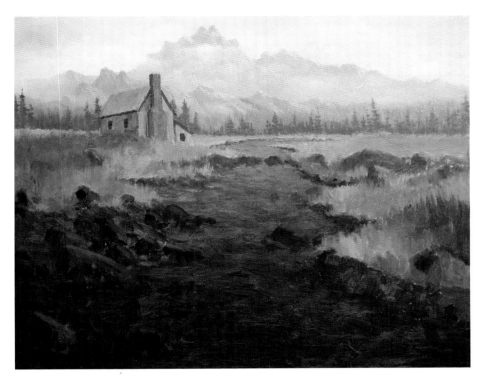

11 Underpaint the Meadow

This scene is set in early Fall, so you'll want to have a variety of mottled olive, mustard, green, gold and rust colors. Just keep in mind that the grasses should be softer and lighter in the background.

Mix 3 parts Hooker's Green with 1 part Burnt Sienna to create a warm green. Scrub in the meadow grasses with a no. 4 or no. 6 bristle flat. Use short, overlapping vertical brushstrokes. Begin in the background and, as you scrub your way forward, add touches of Cadmium Yellow Light, Cadmium Orange, Vivid Lime Green or more Burnt Sienna. Try to create interesting multi-colored light and dark areas. Do not over blend. Remember this is wild, unkept grasses and brush.

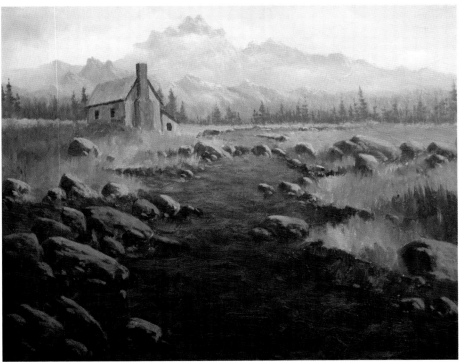

12 Highlight the Rocks

Before you begin adding highlights, you might need to re-shape the rocks or even add additional ones. The most important thing to keep in mind is to make sure you create a good variety of shapes, sizes and angles. Don't line them all up in a row or make them all the same shape or size. You want them overlapping with good negative space.

Mix white with touches of Cadmium Orange and Ultramarine Blue to create a warm soft gray tone. Make it a creamy consistency and load a small amount onto a no. 4 bristle flat. Highlight only the top right side of each rock since the light source comes from the upper right.

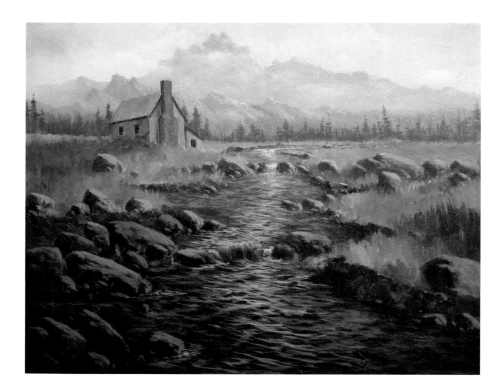

13 Highlight the Water

Mix white with a slight touch of Ultramarine Blue. Thin it to a soupy consistency and load the tip of a no. 2 or no. 4 Dynasty brush. Hold the brush horizontal to the water and paint short, concave, overlapping brushstrokes. Keep the majority of the highlights toward the center of water area and gradually fade them out toward the shoreline.

Repeat this step one more time using a bit more white to brighten the ripples.

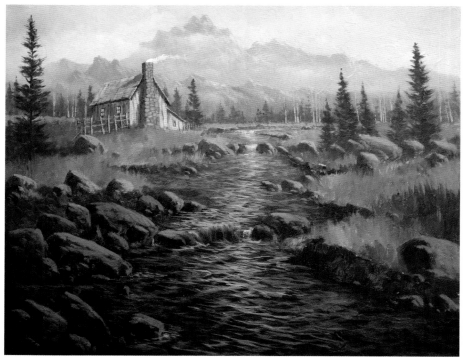

14 Paint More Trees and Detail the Cabin

Mix 3 parts Hooker's Green with 1 part Dioxazine Purple and just enough white to create a medium-dark grayish green tone. Carefully dab on the shape of pine trees in the middle ground with a no. 4 or no. 6 bristle flat. Create interesting pockets of negative space and a variety of shapes, sizes and arrangements.

Load a no. 2 Dynasty brush with a slightly dirty white mixture. Hold the brush vertical to the canvas and dab in the more distant Aspen tree trunks.

Use any of your smaller brushes to brighten the sunlit side of the cabin. Paint stones on chimney, the glow of light in the windows, smoke coming out of chimney, shingles on the roof, and a fence. This is where you can really use your artistic license and have fun with whatever details you wish to add.

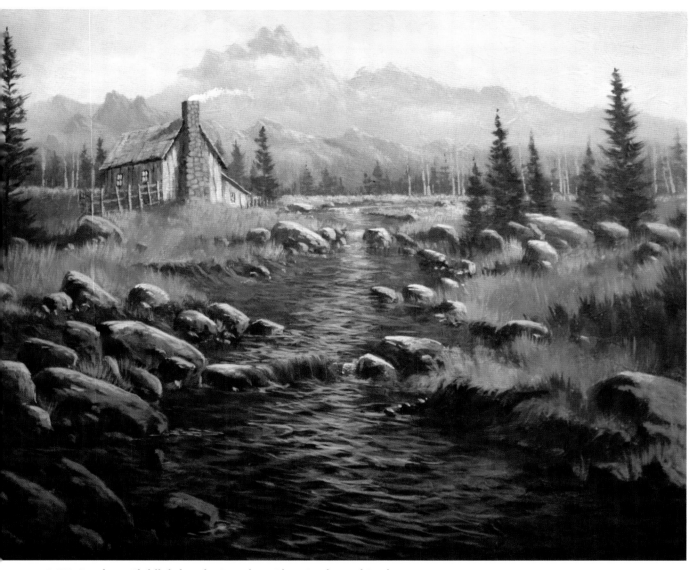

15 Continue Highlighting the Meadow, River Banks and Rocks

Mix 3 parts Hooker's Green with 1 part Burnt Sienna and 1 part Cadmium Yellow Light to get a medium olive green. Highlight the river banks and grasses with a no. 4 bristle flat. As you go along, add Cadmium Yellow Light, Cadmium Orange and Vivid Lime Green for lighter values, and add touches of Dioxazine Purple or Burnt Sienna for darker values.

Then mix white with touches of Cadmium Orange and Ultramarine Blue to create a soft warm gray. You can adjust the brightness of the tone by adding small amounts of white, Cadmium Yellow Light, Cadmium Orange or even Cadmium Red Light to create a slightly pink tint. Highlight the rocks with a no. 4 Dynasty brush or a no. 4 bristle flat. Make the mid ground rocks brighter and the immediate foreground rocks darker. Repeat this step until you achieve the brightness you desire.

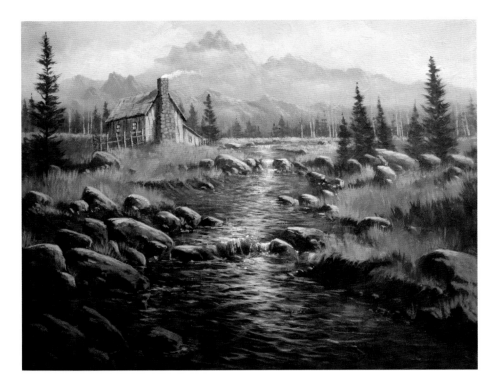

16 Brighten the Water Highlights and Add Reflections

Scrub in some more grass tones along the river banks with a no. 2 or no. 4 bristle flat. Be careful not to make them too bright. Then scrub reflections of the larger boulders (both the shadows and highlights) into the water. Again, be careful not to overdo it.

Add brighter highlights on the water with white and a no. 2 Dynasty brush. The brightest highlights should stay toward the center of the water.

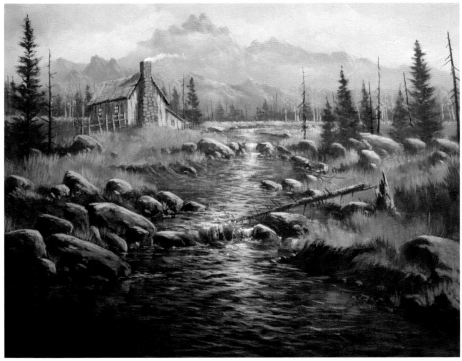

17 Continue Building and Refining the Composition

Mix a medium charcoal gray tone and use a no. 2 Dynasty brush to paint a log in the water and some bare pine trees scattered across the middle ground. Then mix white with a touch of Cadmium Orange and highlight them.

Dab in the Aspen leaves with a no. 2 bristle flat and a combination of Cadmium Orange and Cadmium Yellow Light.

If you will look in the lower-left corner of the water, you will notice the large rocks that were there previously have been removed. After studying this area for a while, I realized that the painting was already fairly busy, and those particular rocks were not helpful or useful to the composition. I painted over them using the same process for underpainting the river.

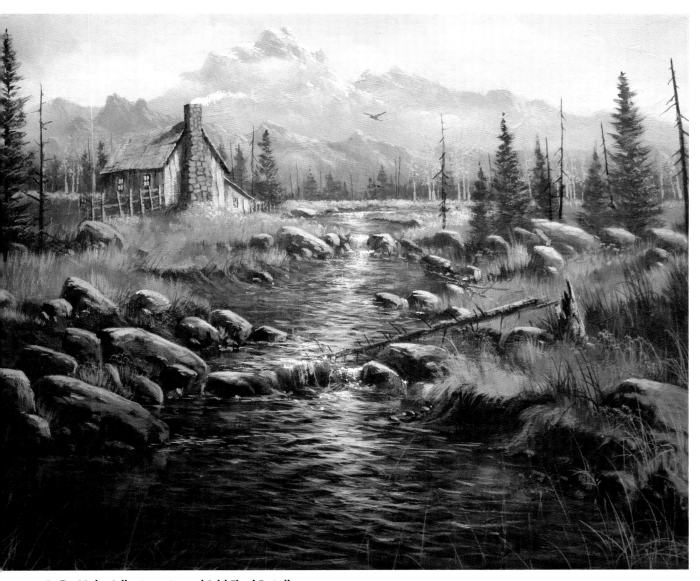

18 Make Adjustments and Add Final Details

Think of this part as the "beauty step." Sometimes you will not see much that you want to add or change, and other times you will want to make several final additions. In this painting, you could add a few mountain flowers, some tall weeds in the foreground, birds in flight or, perhaps, a little snow on the mountain peaks. If adding flowers, gently dab on the color with a no. 2 or no. 4 bristle flat. Use white and a no. 4 sable flat to dab snow on the mountain peaks. Tall weeds can be added with a no. 4 sable script and an inky mixture of dark and light tones. The key is to keep it simple and not overdo it.

Paint a Chicken Farm

MY CHICKEN COOP

Many people paint in order to relieve stress and anxiety. For me though, after a long day of teaching painting or taping the TV show, nothing helps melt the stress away like spending time with my chickens. Yes that's right—I raise chickens. And they are a 24/7 comedy act.

But beyond that, chickens make great painting subjects. The entire setting of this stark winter scene with the cedar chicken coop, chicken wire, roosts, feeding containers and dirt ground scattered with straw and pebbles offers an amazing array of artistic opportunities. The chickens are an added bonus. The coop and all its components are more of a challenge than you might think, but the process involved in painting this composition will no doubt inspire you.

Materials

SURFACE
16" × 20"
(41cm × 51cm)
stretched canvas

ACRYLIC PIGMENTS
Burnt Sienna, Burnt Umber, Cadmium Orange, Cadmium Red Light, Cadmium Yellow Light, Dioxazine Purple, Hooker's Green, Ultramarine Blue

BRUSHES
- nos. 2, 4, 6 and 12 bristle flats
- nos. 2, 4 and 6 Dynasty
- no. 4 sable flat
- no. 4 sable round
- no. 4 sable script

OTHER
- medium or firm toothbrush
- soft vine charcoal
- white gesso

1 Prepare the Canvas and Sketch the Composition

Use a no. 12 bristle flat to apply a warm gray tint to the canvas. Let it dry. Then use soft vine charcoal to make a rough sketch of the main components of the distant landscape, chicken coop and related objects. The coop takes up most of the composition, so there is not much room to create depth or distance. Here, I left a section of negative space to the left of the coop and a small section on the right. This will be enough area to create at least three values, resulting in a little depth. You can decide where to put the chickens later.

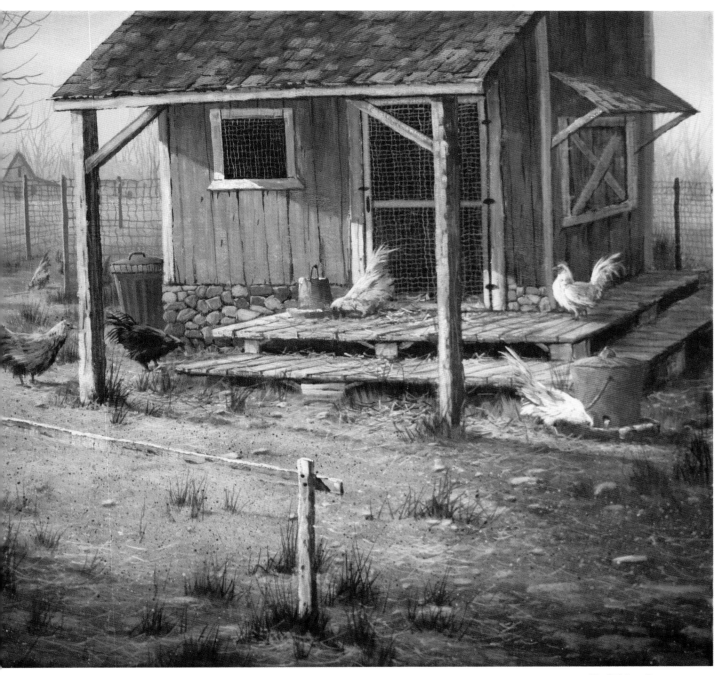

My Chicken Coop
Acrylic on canvas
16" × 20" (41cm × 51cm)

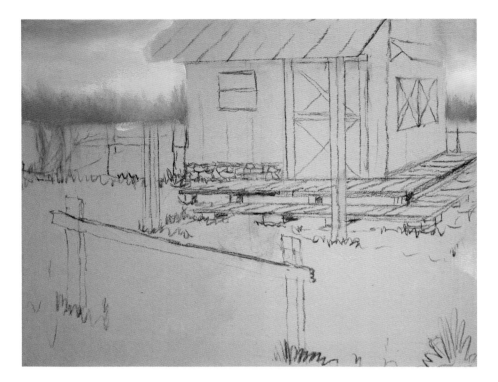

2 Underpaint the Sky

Use a no. 6 bristle flat to paint white across the sky area. At the horizon, add Cadmium Red Light with a touch of Cadmium Orange and blend it about halfway way up. Rinse the brush.

Take a small amount of Ultramarine Blue, add a touch of Dioxazine Purple and paint across the top of the sky, blending downward. Use this same color mixture to scrub in some distant trees along the horizon. Be sure to do this on both sides of the coop.

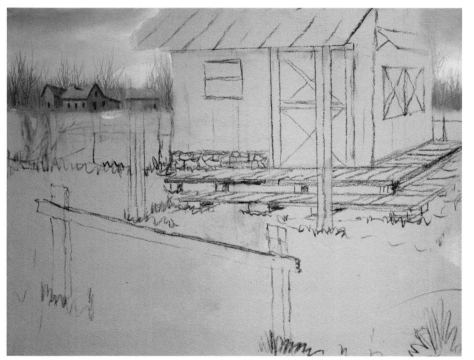

3 Paint the Distant Houses

Mix a soft light gray value and load it onto the tip of a no. 2 Dynasty brush. Use simple brushstrokes to create the basic form of small houses in the background. The light source is coming from the left side, so make sure the left sides of the buildings are sunlit. Use a no. 4 sable round or no. 4 sable flat to paint in minor details like doors and windows.

Mix 3 parts white with 1 part Ultramarine Blue, then add touches of Burnt Sienna and Dioxazine Purple to get a medium gray tone about two values darker than the horizon. Thin it to an ink-like consistency and paint in the trees along the horizon line with a no. 4 sable script.

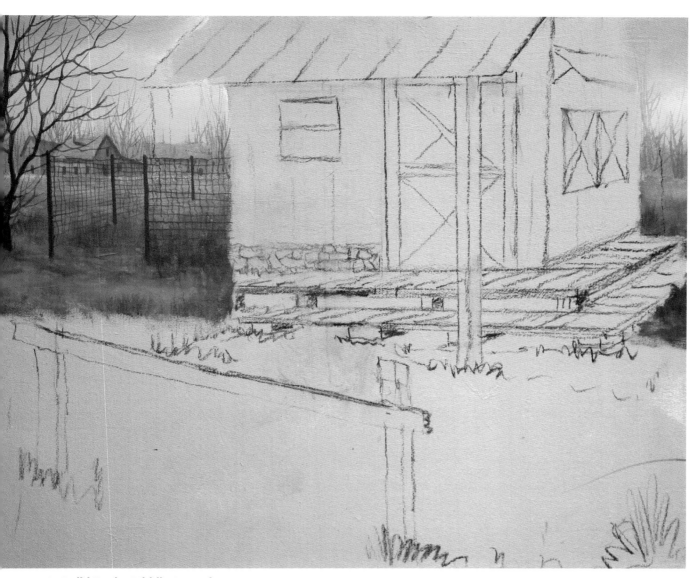

4 Build Up the Middle Ground

Paint in the ground area up to the base of the chicken coop. Starting at the area below the houses, use a no. 4 or no. 6 bristle flat and short, choppy horizontal brushstrokes to apply different colors. Start with white, then mottle in touches of Burnt Umber, Hooker's Green, Dioxazine Purple and Cadmium Yellow Light. Do not be afraid to use a few vertical brushstrokes here and there to suggest clumps of grass or brush.

Once dry, mix a medium gray tone and paint in the fence with a no. 4 sable script. The fence should be about two values darker than the background houses and trees.

Mix 3 parts Burnt Umber and 1 part Ultramarine Blue with just enough white to create a medium-dark value. Switch back-and-forth between a no. 4 sable flat and a no. 4 sable round to block in the tree trunk and main limbs. Then thin the mixture to an ink-like consistency and finish out the tree limbs with a no. 4 sable script. Make sure you have plenty of overlapping limbs to create interesting pockets of negative space.

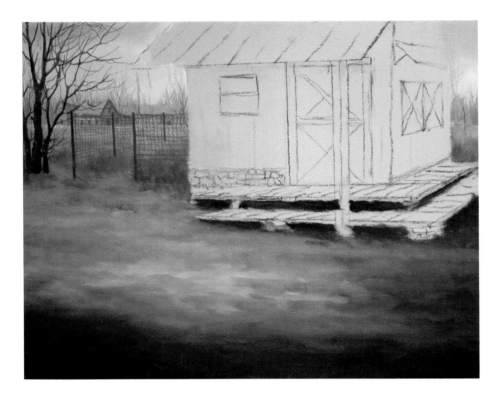

5 Underpaint the Foreground

Underpaint the remaining ground area. Keep in mind this is dirt, small rocks, pebbles and clumps of grass—so you want your brush-strokes to be rough, loose and choppy. Keep the values lighter in the back by the coop and gradually darken them as you come forward. Most of this can be done with a no. 4 or no. 6 bristle flat. Start at the base of the coop and begin applying various earth tones like Burnt Umber mixed in with some Cadmium Yellow Light and touches of Hooker's Green, Dioxazine Purple and Ultramarine Blue.

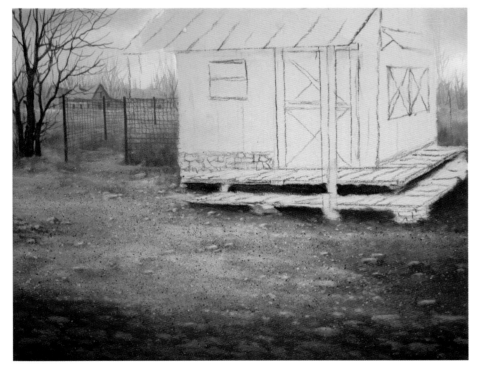

6 Continue Building Up the Foreground

Mix Burnt Umber with touches of Ultramarine Blue, Dioxazine Purple and just enough white to create a medium-dark value. Throughout the mid ground and foreground, block in the suggestion of chunks of dirt and small rocks with a no. 4 sable flat. Take a small amount of the color and lighten it substantially, then use a no. 4 sable round to highlight the various shapes and give them form. It's also a good idea to scatter this color throughout the dirt area to suggest sunlight.

Use a medium or firm tooth-brush to splatter a large variety of colors and values in the foreground dirt to create the effect of pebbles. Do not be afraid of overdoing this, just make sure you have a good variety of pebble sizes.

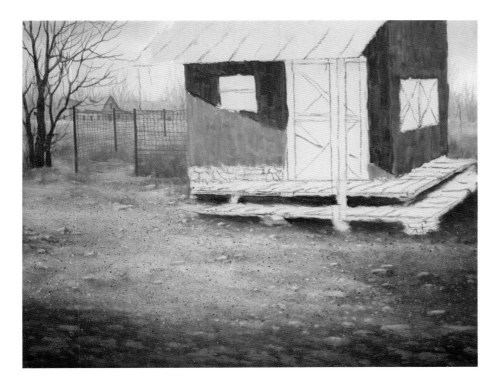

7 Begin Blocking In the Chicken Coop

Mix 3 parts Ultramarine Blue with 1 part Burnt Sienna and just enough white to create a medium-dark value. You can warm or cool this mixture as you like by adding more Burnt Sienna or Ultramarine Blue. Use a no. 6 Dynasty brush and long vertical brushstrokes to block in the shadowed areas of the chicken coop.

Note that the angled shadow under the roof is the cast shadow. Lighten the mixture by about three values and block in the sunlight section under the roof.

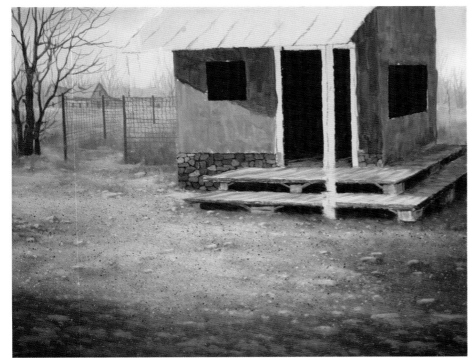

8 Paint the Dark Areas, Foundation and Planks

Darken the mixture from the previous step by adding Burnt Umber, Ultramarine Blue and a touch of Dioxazine Purple. Use a no. 4 bristle flat to block in the dark areas of the coop like the front door, window, stone foundation and the areas just beneath and immediately around the decks.

Use a no. 2 or no. 4 Dynasty brush to paint in the foundation stones using a variety of earth tones. Mix a base color from 3 parts white and 1 part Burnt Umber. As you paint each stone, begin adding other colors to the base, like touches of Cadmium Red Light, Cadmium Orange, Ultramarine Blue, Burnt Sienna or Cadmium Yellow Light. Add touches of white to create subtle value changes.

Now take the original base color and make it grayer by adding a bit of Ultramarine Blue. Paint in the deck planks with a no. 4 Dynasty brush. Pay close attention to the dark and light areas and paint them in accordingly.

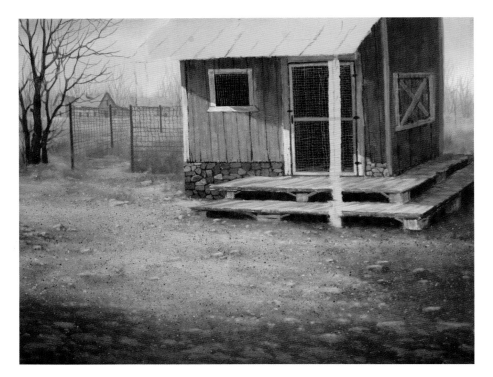

9 Continue Refining the Chicken Coop

Lighten the mixture you used to paint the deck planks and then add a touch of Cadmium Red Light to give it a reddish tint. Thin it to almost a glaze and load the tip of a no. 4 Dynasty brush. Drybrush the tint on the walls of the coop to create a weathered, faded paint effect.

Use a no. 4 sable script and a light gray tone to paint the suggestion of chicken wire on the door and small window. Then switch to a darker tone (almost a black) and paint cracks in the wood. Finish out the trim work around the doors and windows with whichever brush works best for you. Just pay close attention to the light and the shadows. Do not be afraid to add your own personal touches.

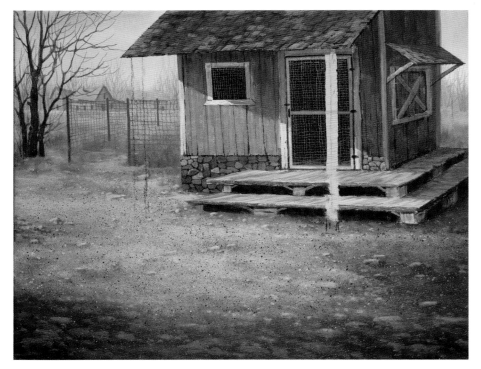

10 Paint the Roofs

Mix Cadmium Red Light with a small amount of Dioxazine Purple. This should create a deep burgundy. Use a no. 4 or no. 6 Dynasty brush to paint in the roof of the coop with long, angled brushstrokes. Once the roof is dry, add a little white and a touch of Cadmium Orange to the mixture to create a highlight color. Use short, choppy angled brushstrokes to suggest shingles. Then use a no. 4 sable script and the same dark mixture you used for the cracks in the wall to paint some dark cracks in the roof area. This will help identify the shape of the shingles.

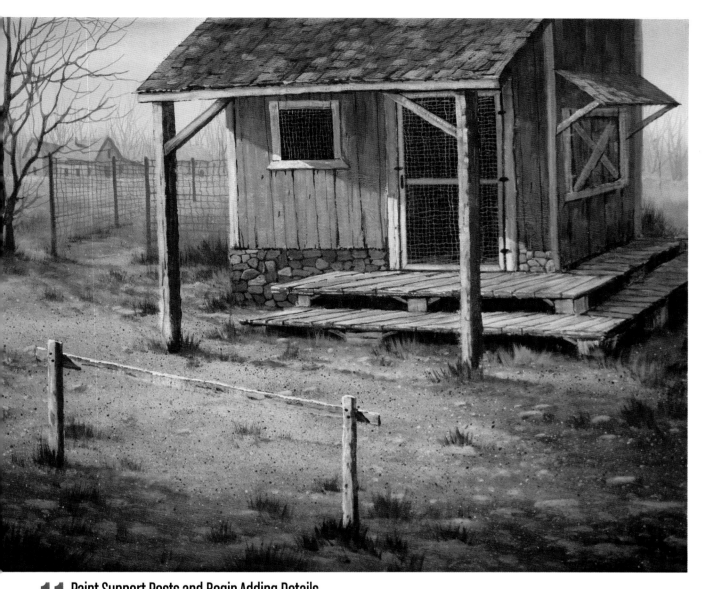

11 Paint Support Posts and Begin Adding Details

Create a creamy dark charcoal gray tone by mixing 3 parts Burnt Umber with 1 part Ultramarine Blue. Add a small amount of white. Paint in the shadowed side of the roof and the roost posts with a no. 4 Dynasty brush.

Lighten the mixture by about three or four values with more white, then add a touch of Cadmium Orange. Paint in the highlighted side of the support posts. Then switch to a no. 4 sable script and paint a few cracks and holes in the posts to give them an old, weathered effect.

Mix Hooker's Green with touches of Dioxazine Purple and Burnt Sienna to create a dull warm grayish-green tone. Load a no. 4

Dynasty brush and paint in several clumps of grass throughout the middle and foreground using upward, drybrush strokes. Be sure to paint some grass clumps at the base of the tree, the coop and the posts to seat them.

Add a touch more Dioxazine Purple to the mixture and use a no. 2 bristle flat to scrub in the cast shadow color for the tree, posts, roost and right side of the coop. Then switch to a no. 4 sable script and paint in dark cracks on the deck planks. Be sure the cracks are properly perspected

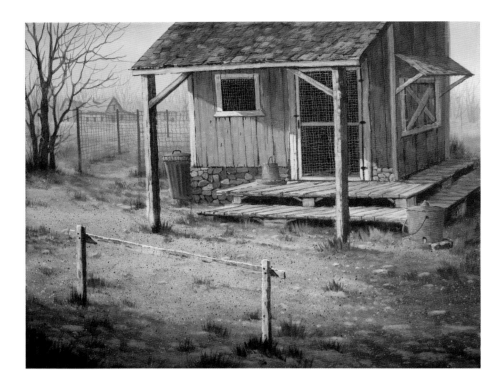

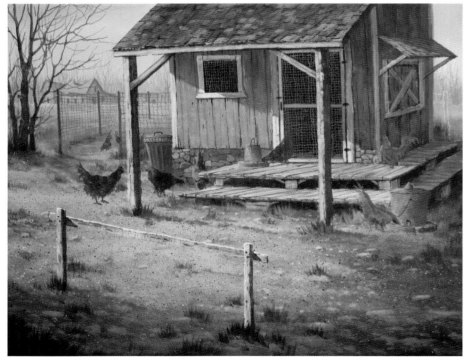

12 Paint the Water and Feed Containers

Lightly sketch in some water containers and a large feed can with soft vine charcoal. Use your smaller brushes to underpaint each item with a medium warm gray tone. Then apply one or two layers of lighter colors of your choosing. Add a touch of white to make it opaque and lighten it, then highlight the sunlit side of each object. If you keep these objects bright and colorful, they will add interest to the color scheme of the composition.

13 Underpaint the Chickens

Lightly sketch in some chickens with soft vine charcoal. Be sure you are happy with the shape, size, proportion and location of each chicken before moving on. Underpaint each bird with a dark value just as you did with the objects in the previous step. Here are a few possibilities: For brown chickens, use pure Burnt Umber. For reddish-brown chickens, use an equal mix of Burnt Umber and Burnt Sienna. For black chickens, use an equal mix of Burnt Umber and Ultramarine Blue. For white chickens, use a medium gray tone. Of course, these are all just basic mixtures, so you may have to do some experimenting.

Once you have chosen your color, underpaint the chickens using a no. 4 sable flat and no. 4 sable round for the small areas, and a no. 2 or no. 4 bristle flat for the large areas. Remember to keep all your edges soft, which will make highlighting much easier in the next step.

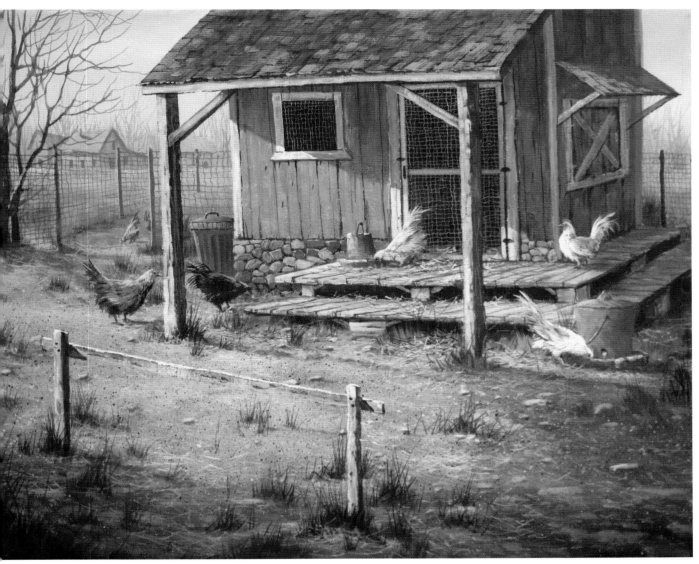

14 Highlight the Chickens, Make Adjustments and Add Final Details

To highlight the chickens, simply add small amounts of white to your under-painting colors. Make your mixtures creamy and use small sable brushes to begin layering on the appropriate highlight colors. Apply the highlights in multiple layers until you achieve the color and brightness you want.

Step back and evaluate your painting. Make any corrections you feel are necessary. Then finish by adding in the straw, sticks and various final details on the ground. Use a no. 4 sable script to create inky mixtures of various dark and light values of different colors. Then load your brush and have fun making lots of overlapping, squiggly lines all over the middle and foreground until it begins to look like straw and dead grass. If you like, you can use a toothbrush to add a few more splatters.

Tip The best average viewing distance from a painting is about 6 feet (1.8m) away. Stand back and evaluate your work often.

Paint a Rocky Shoreline

BEACON OF HOPE

I have had the great joy of visiting, photographing and studying many lighthouses set amongst rugged shorelines. Each lighthouse has its own story to tell. It takes a unique kind of person to live in and operate one of these giants. A lonely existence to be sure, but the mission of lighthouse keepers is greater than themselves. The hope felt by countless sailors who finally saw that beacon of light bursting through stormy skies is a true testament to the courage of these men and women who help guide weary ships home to safety.

Because this book focuses on adding buildings to a landscape, I thought it would be fun and informative to paint one of these magnificent structures towering above winter waves crashing against rock formations. This will be an exciting artistic challenge.

Materials

SURFACE
20" × 16"
(51cm × 41cm)
stretched canvas

ACRYLIC PIGMENTS
Burnt Umber,
Cadmium Orange,
Cadmium Red Light,
Cadmium Yellow Light,
Dioxazine Purple,
Hooker's Green,
Turquoise Deep,
Ultramarine Blue

BRUSHES
- 2" (51mm) hake
- nos. 2, 4, 6 and 10 bristle flats
- nos. 2, 4 and 6 Dynasty
- no. 4 sable flat
- no. 4 sable round
- no. 4 sable script

OTHER
- medium or firm toothbrush
- soft vine charcoal
- white gesso

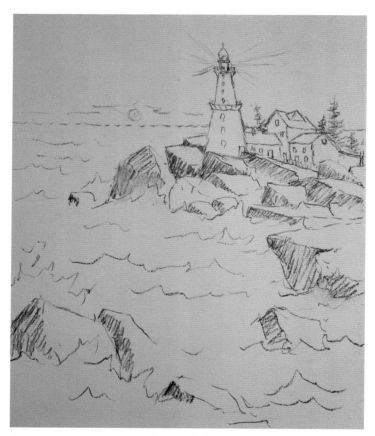

1 Prepare the Canvas and Sketch the Composition

Apply a warm gray tint to the canvas with a 2" (51mm) hake brush. Let it dry. Then use soft vine charcoal to make a rough yet accurate sketch of the main components of the composition. You don't have to copy this lighthouse and composition exactly—use your artistic license and create your own design if you wish.

I recommend taking a photo or making another sketch for reference because you will lose most of the sketch as you do the underpainting.

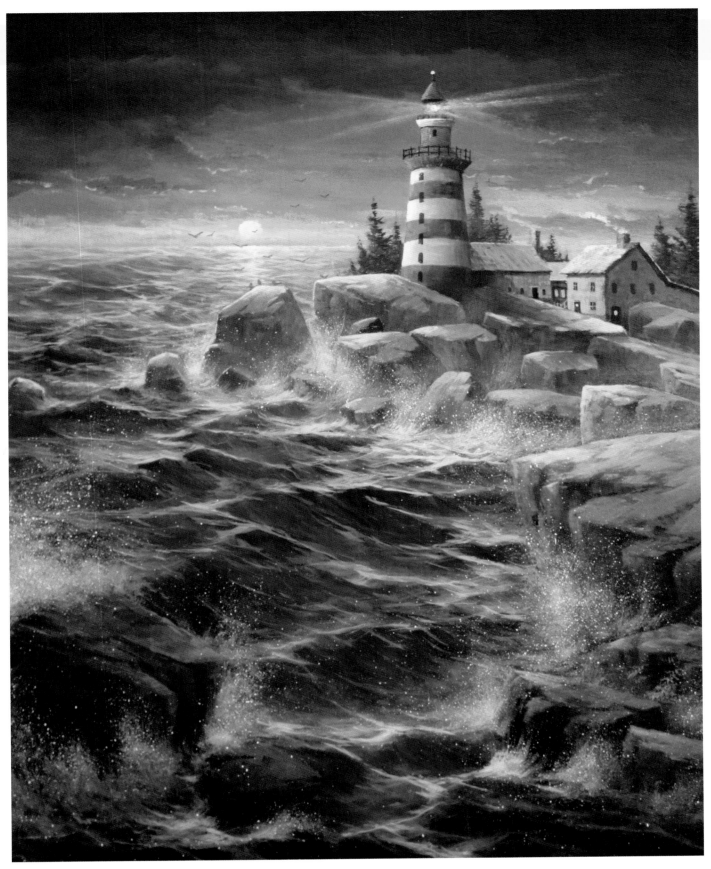

Beacon of Hope
Acrylic on canvas
20" × 16" (51cm × 41cm)

2 Underpaint the Sky

Use a 2" (51mm) hake brush to paint Cadmium Red Light and a small amount of Cadmium Yellow Light across the horizon. Blend upward, adding white until it fades out.

Mix 3 parts Ultramarine Blue with 1 part Turquoise Deep and add touches of Dioxazine Purple and Burnt Umber. This will create a deep midnight blue color. Make it a creamy consistency. Beginning at the top of the sky, paint the blue color downward. Carefully blend the two tones where they meet.

3 Paint the Clouds and Sun

Load a no. 4 or no. 6 bristle flat with a small amount of the midnight blue mixture from the previous step. Add a touch of white to create a medium value that is about two values lighter than the dark sky. Begin scrubbing in horizontal clouds. The key is to create interesting pockets of negative space and to keep most of the clouds toward the lower-middle part of the sky.

Mix Cadmium Yellow Light with a slight touch of Cadmium Orange and a small amount of white. Paint in the sun with a no. 4 sable flat. If you decide you want to have brighter colors along the horizon, this would be the time to add more Cadmium Yellow Light, Cadmium Orange or Cadmium Red Light.

For the silver linings on the darker clouds, mix white with a touch of Cadmium Yellow. Use a no. 4 sable round to carefully paint thin segmented lines on the top and bottom edges of some of the clouds closest to the sun. Stand back and study your sky,. Make any changes or additions you feel are necessary. You can even add sun rays coming through the clouds if you like.

4 Underpaint the Middle and Background Water and Rocks

Take the midnight blue mixture you used in the previous step and use a no. 6 bristle flat to paint short, overlapping choppy brushstrokes across the horizon line. (I like to call them lazy bananas.) Begin adding white to create lighter values along the horizon as you apply the color. Continue working your way downward and make sure you are adding enough white to create a gradated value system from light to dark. Use choppy brushstrokes to create the suggestion of waves or rough water.

Next, underpaint the rock formations that the lighthouse and buildings sit upon. Mix equal parts Burnt Umber and Ultramarine Blue with touches of Dioxazine Purple and white to create a medium gray value. Use a no. 6 bristle flat or a no. 6 Dynasty brush to block in the basic shape of the shadowed side of the large rock formations. Remember this is only the underpainting. You will make numerous changes to the shape, proportion and size as you progress. So just keep this stage simple and loose. Do not be afraid to leave brushstrokes showing.

5 Add Form Highlights to the Rocks

Take the mixture you used to underpaint the rocks in the previous step and add just enough white to lighten the color by about two values. Use a no. 4 or no. 6 Dynasty brush to block in form highlights on the rocks using quick, clean, decisive brushstrokes. This will help define their basic shape.

As with previous step, you can leave brushstrokes showing. This is only the rough basic form, so don't go overboard trying to make a finished shape.

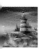

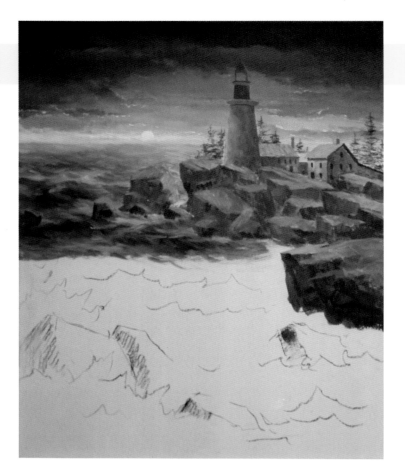

6 Underpaint the Lighthouse and Buildings

Just like you did with the rock formations, you'll want to create the shadowed side and form highlights of the lighthouse and buildings to give them their basic form. All of the details, highlights and colors will be added in the next few steps.

Use soft vine charcoal to more accurately re-sketch the lighthouse and buildings. Then take the same mixture that was used for the rock tones in the previous step and use a no. 2 or no. 4 Dynasty brush to underpaint the lighthouse and other buildings with soft warm gray tones of light and dark values.

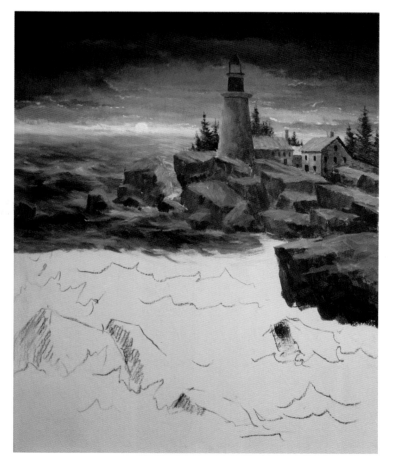

7 Paint the Trees

Paint in the wind-blown pines and cedars behind the lighthouse and other buildings. Mix 3 parts Hooker's Green with 1 part Dioxazine Purple. Make it a creamy consistency. Load a no. 2 bristle flat and gently tap in the shape of the trees. If you are struggling with this brush, go ahead and finish the trees out with a no. 4 sable round.

Tip Paint with quick, clean, decisive brushstrokes—and keep them limited. Too many brushstrokes will kill a painting.

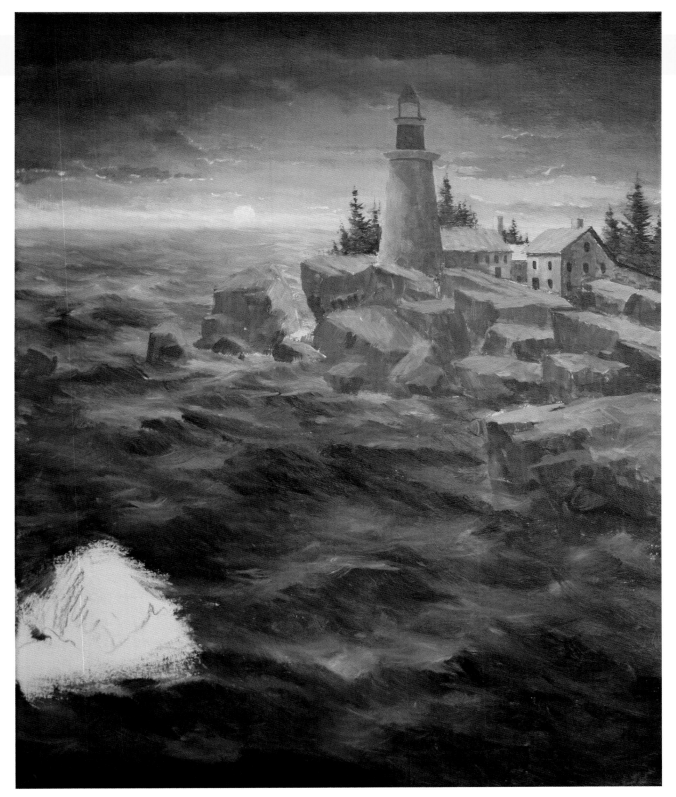

8 Finish Underpainting the Water

Load a no. 10 bristle flat with the midnight blue mixture you used for the sky in Step 2. Begin painting in moving water in the middle and foreground. Add touches of white and Hooker's Green as you go along to create various value and color changes. This is fairly turbulent water, so you'll want to use broad, bold brushstrokes here. Keep it loose and free.

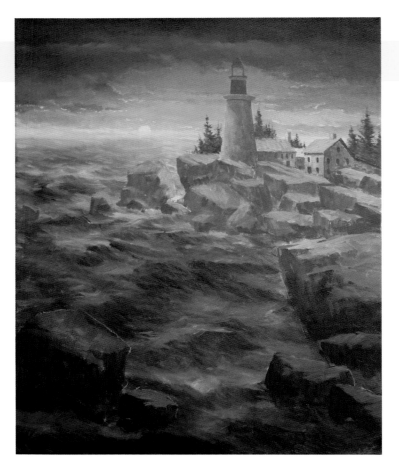

9 Underpaint the Foreground Rocks

Mix 3 parts Ultramarine Blue with about 1 part Burnt Umber and a touch of Dioxazine Purple. This will create a dark, almost black color. Block in the shadow side of the rocks with a no. 6 bristle flat and quick, bold brushstrokes. Then add a little white to slightly change the value to a medium-dark gray. Paint in the form highlight.

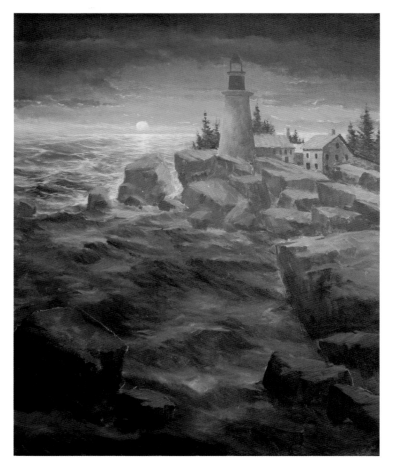

10 Add Highlights and Details

Mix white with a slight touch of Cadmium Yellow Light. Use a no. 4 sable round to highlight the sun using fairly thick paint. This will make it more opaque and much brighter.

Thin the mixture down to a creamy consistency and, with the same brush, begin highlighting the water with loose horizontal, elliptical, overlapping brushstrokes. Be sure to create interesting pockets of negative space. Make the brightest highlights directly below the sun and moving toward the rock formations.

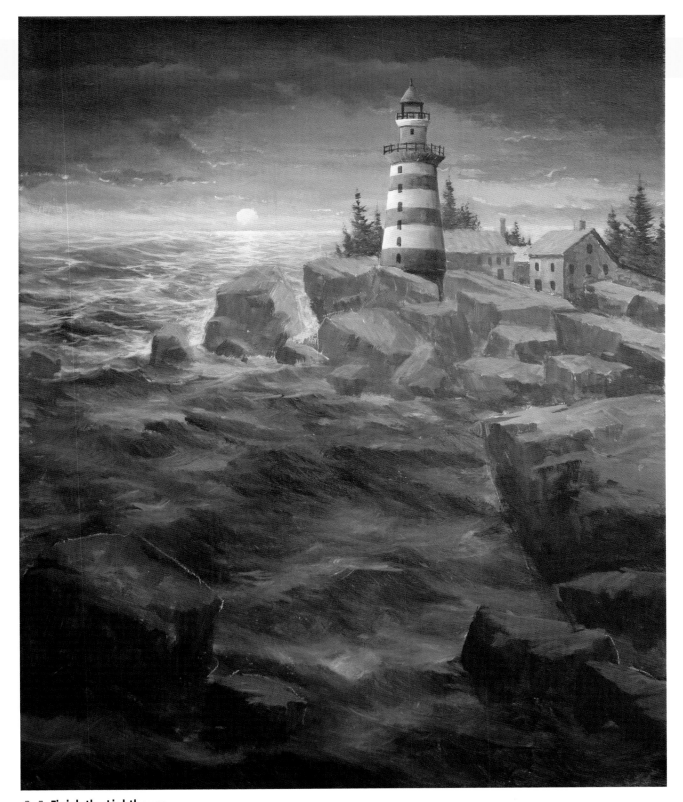

11 Finish the Lighthouse

There are many shapes, sizes, colors and styles of lighthouses. You can copy the one I have painted here, or do your own research and create your own. Whichever you choose, the process of painting and detailing the lighthouse is the same. The main thing is to make sure that it has good three-dimensional form.

You will notice the lighthouse is much brighter on the left side and gradates to a darker value as you move to the right side. No matter what colors you use, you need a light-to-dark value change. I recommend using a no. 4 sable flat and no. 4 sable round for most of the blending, and then switching to a no. 4 sable script for the small details.

12 Highlight and Detail the Buildings

Just as with the lighthouse, there are many ways you can detail the other buildings. Pay close attention to the highlights and shadows while creating the contrast needed for each building to form its own shape. Keep in mind these buildings are fairly far off in the distance, so be careful not to over detail.

Use a no. 2 Dynasty brush for most of the roofs and sides of the buildings, and use a no. 4 sable flat or round for the smaller details. Keep whatever mixtures you create a creamy consistency—this makes it easier to apply the color.

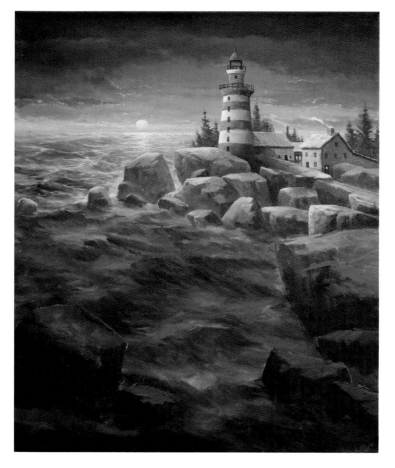

13 Continue Highlighting the Rocks and Water

Mix white with touches of Cadmium Orange and Ultramarine Blue. Load a small amount onto a no. 2 Dynasty brush and begin highlighting each rock. Keep in mind that the rocks are all at different angles, so the highlights will be mostly on the top-left side. You may have to add additional shadows of dark-to-medium values of gray to adjust the shape of the rocks. Make sure that you only highlight the rocks that are behind the large rock on the right.

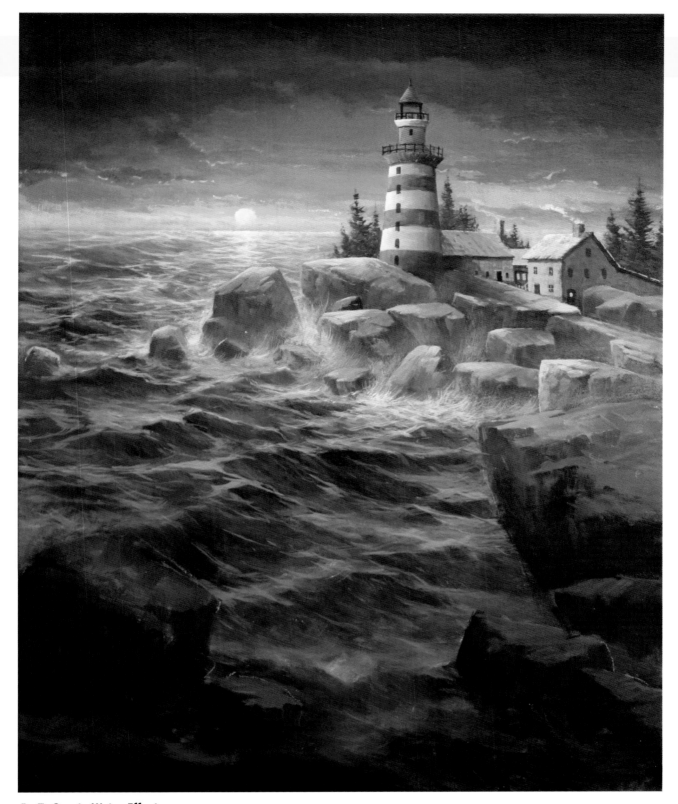

14 Create Water Effects

Mix white with touches of Ultramarine Blue and Dioxazine Purple. Load a small amount onto a no. 4 bristle flat and begin scrubbing in mist around the rocks. Add more white to the mixture and use a no. 4 Dynasty brush to paint waves splashing up against the base of the rocks. Then thin the mixture and begin highlighting the water throughout the middle-ground area. Use loose, overlapping brushstrokes to give the water good movement with interesting pockets of negative space.

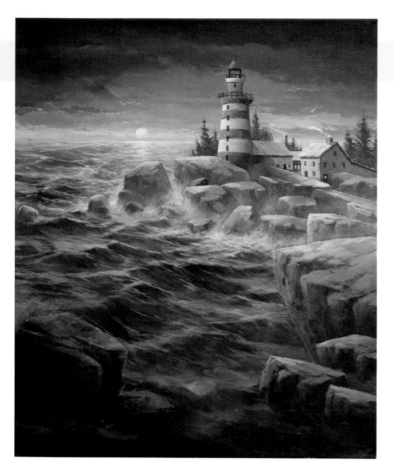

15 Finish the Foreground Rocks

This step follows the same process you used to finish the background rocks in Step 13. The only difference here is that you'll want to use bigger, bolder brushstrokes that create the suggestion of rugged, wind-blown eroded shapes. I recommend using nos. 4 and 6 Dynasty brushes for this.

Mix white with touches of Cadmium Orange and Ultramarine Blue to create a soft warm highlight. For brighter highlights just add more white to the mix. For shadows, use equal parts Ultramarine Blue and Burnt Umber, then add whatever amount of white is needed to achieve the proper value.

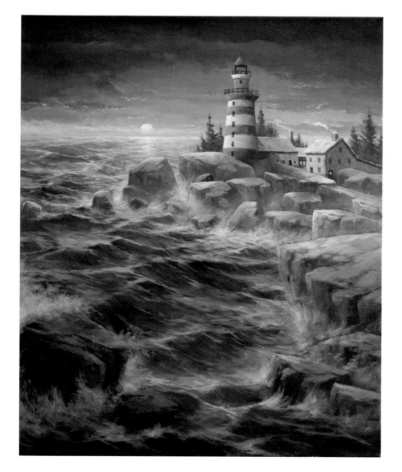

16 Finish the Waves

Mix white with slight touches of Ultramarine Blue and Turquoise Deep. Load the tip of a no. 6 Dynasty brush and paint on the caps of the waves. Make sure you have good contour, good eye flow and interesting pockets of negative space. Add more white to the mix and use a no. 6 bristle flat to smudge up the splashing of the waves.

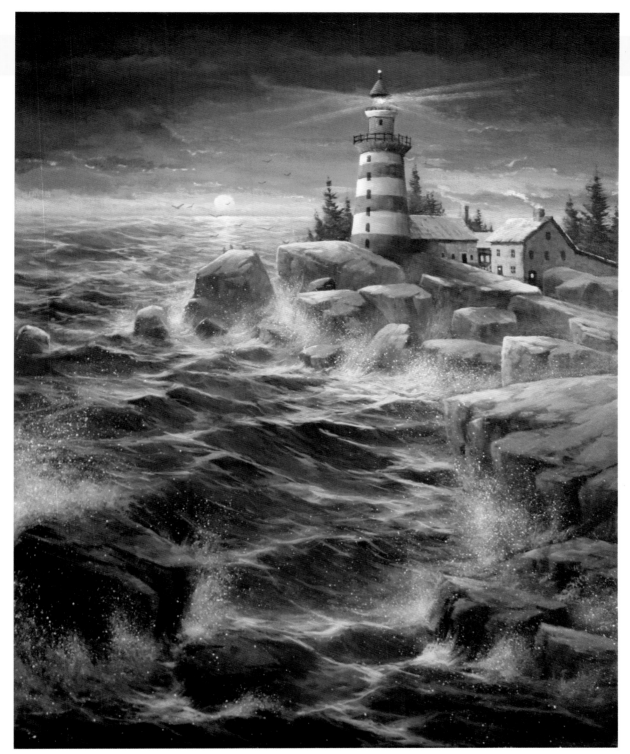

17 Make Adjustments and Add Final Details

Load a medium or firm toothbrush with white. Splatter the crashing waves to lighten them and add more mist. Thicken the mix a little, and use a no. 4 Dynasty brush to brighten the caps on top of the waves. Repeat both of these steps as needed until you are happy with the brightness.

Use a small dab of white with Cadmium Yellow Light in the center to paint the glow of the lighthouse lamp. Drybrush out the rays with a no. 2 bristle flat.

Use a no. 4 sable script to add a few birds.

Highlight the tops of some of the rocks and any other finishing touches you like. Just be careful not to overwork your painting.

Paint a Moonlit Village

GATHERING PLACE

Almost every artist I know enjoys including some type of atmospheric condition in their paintings. Fog, rain, mist, wind, smoke and others are wonderful ways to turn a seemingly ordinary painting into a masterpiece. You can change the setting, season, time of day, color scheme and many other components of a painting, but when you add atmospheric elements like fog and mist, the "wow" factor really kicks in.

The artistic challenge in this painting is to keep it simple and not over-detail the buildings and other objects. Remember to keep the mist and fog the main features. The mix of warm and cool tones, soft hazy atmosphere, the warm glow of the lights in the windows and smoke from the chimney truly take us back to a feeling of days gone by. The silhouette of people walking through the cold, damp mist to the warmth of home tells the whole story.

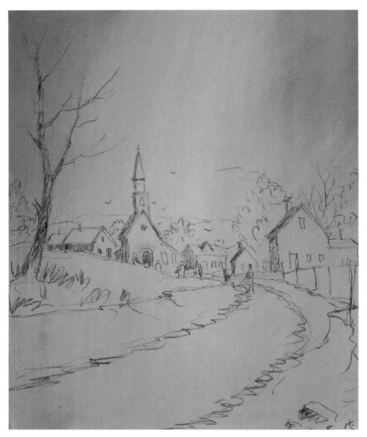

Materials

SURFACE
20" × 16"
(51cm × 41cm)
stretched canvas

ACRYLIC PIGMENTS
Burnt Sienna, Burnt Umber, Cadmium Orange, Cadmium Red Light, Cadmium Yellow Light, Dioxazine Purple, Hooker's Green, Ultramarine Blue

BRUSHES
- 2" (51mm) hake
- nos. 2, 4 and 6 bristle flats
- no. 2 Dynasty
- no. 4 sable flat
- no. 4 sable round
- no. 4 sable script

OTHER
- medium or firm toothbrush
- soft vine charcoal
- white gesso

1 Prepare the Canvas and Sketch the Composition

Mix 3 parts Ultramarine Blue with 1 part Burnt Sienna, a small amount of Dioxazine Purple and just enough white to create a medium mauvish-gray tone. Use a 2" (51mm) hake brush to cover the entire canvas, adding touches of white as you go to create light and dark areas. Once dry, make a rough sketch of the land contours, buildings and other important elements of the composition with soft vine charcoal. Do not worry about sketching any people or miscellaneous objects at this point.

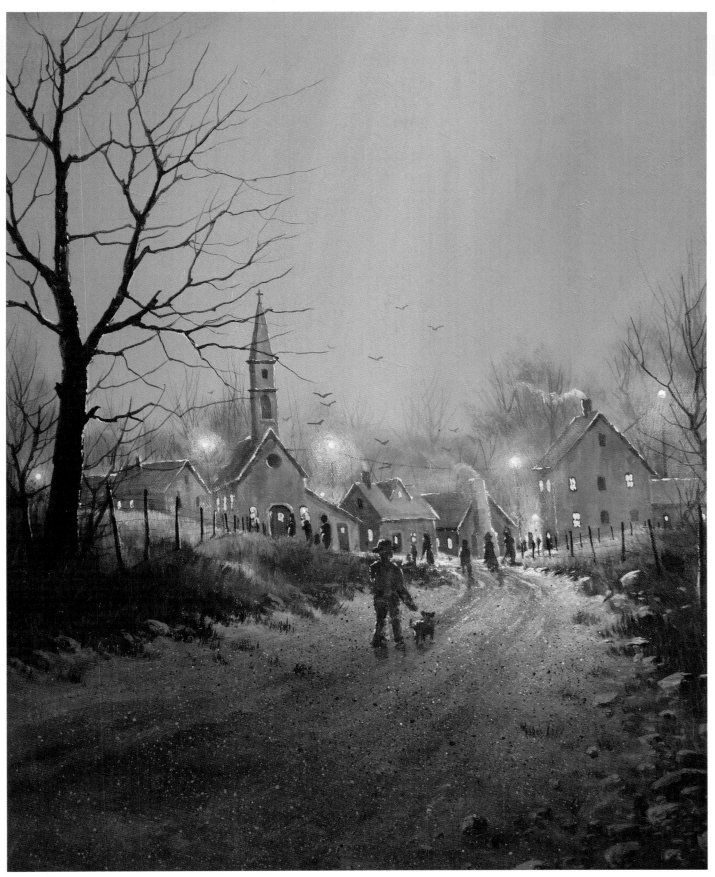

Gathering Place
Acrylic on canvas
20" × 16" (51cm × 41cm)

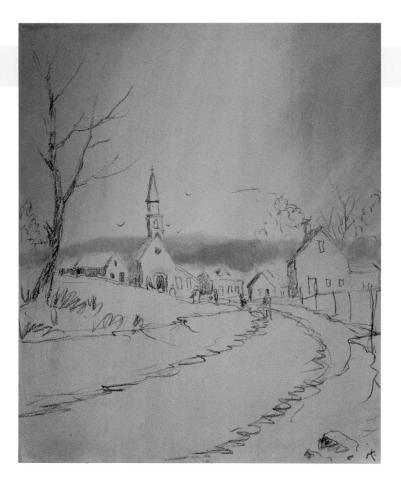

2 Establish the Distant Hills

Mix of Ultramarine Blue with touches of Dioxazine Purple and Burnt Sienna. Add enough white to make the mixture one or two values darker than the sky. Use a no. 2 or no. 4 bristle flat and short, choppy vertical brushstrokes to paint in the distant hills. Keep the edges soft. This will establish the distance and tone of the painting.

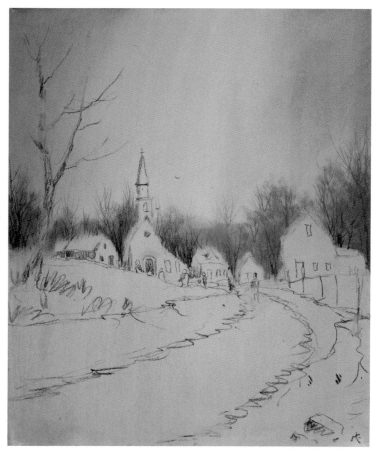

3 Paint the Background Trees

Take the color mixture you used for the hills in the previous step and add small amounts of Burnt Sienna, Dioxazine Purple and Ultramarine Blue to darken and warm it up. It's easy to go too dark, so do some testing on a scrap canvas before you begin. Use a no. 4 bristle flat and short, light feather brushstrokes to skim the surface of the canvas and form tree shapes.

Then darken the color mixture again so it's about one shade darker than the trees. Thin it to an ink-like consistency. Load a no. 4 sable script and paint in the tree limbs all the way across the background. Be sure to create a good variety of shapes and sizes.

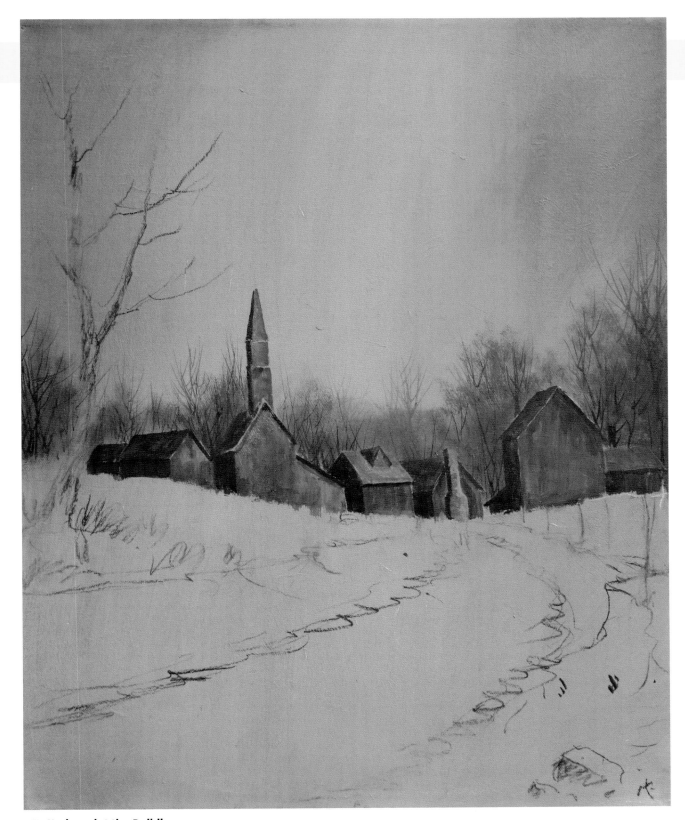

4 Underpaint the Buildings

Mix Ultramarine Blue with a touch of Burnt Sienna and just enough white to create a medium gray tone. Use a no. 2 Dynasty brush to block in the shadowed side of the village buildings. Then add a little white to the mixture and underpaint the light side. Add a touch of Cadmium Red Light to the mixture for the roofs.

Keep in mind, this is only underpainting and, because of the foggy, misty late-evening atmosphere, these buildings do not require much detail. All you want to do here is create the basic form shadow and highlight to give them their shape. You will add more details at a later stage.

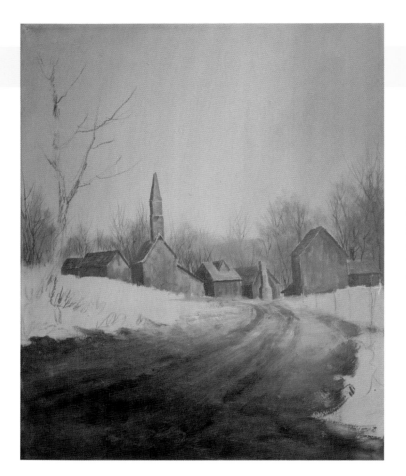

5 Paint the Road

Starting at the bottom, underpaint the road with a no. 6 bristle flat and the same medium gray tone you used for the buildings in the previous step. As you apply the color, begin adding Burnt Umber and small amounts of Dioxazine Purple to darken it. As you work your way upward, begin adding small amounts of white and touches of Cadmium Orange. Be sure you apply fairly thick paint and use brushstrokes that follow the contour of the road. Smudge in the ruts as you go.

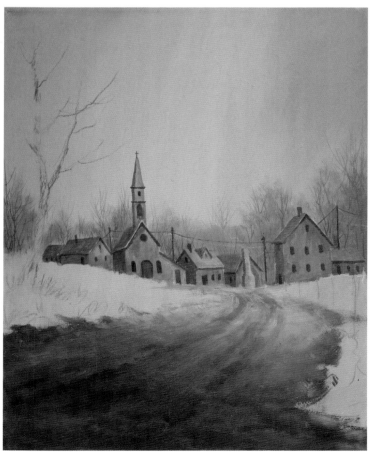

6 Begin Detailing the Buildings

Using your artistic license, paint in the light poles, doors and windows of the buildings a medium-dark gray. This is best done with a no. 4 sable flat, a no. 4 sable round or a no. 4 sable script.

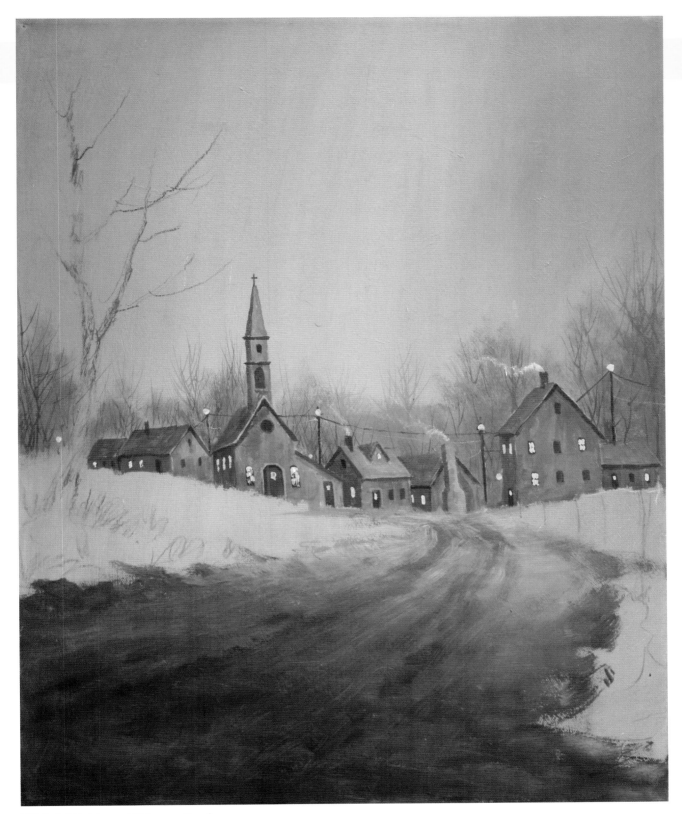

7 Paint Lights and Chimney Smoke

Double load a no. 4 sable round with Cadmium Yellow Light and Cadmium Orange. Dab the color wherever you want lights to be on your buildings and light poles. Then use the same brush to dab a small amount of dirty white at the top of the chimneys. Gently smudge it with your finger to create a soft smoke affect. (To create a dirty white, use any color to kill the chalky effect of pure white. In this case, I used white with a slight touch of Burnt Umber to dull it.)

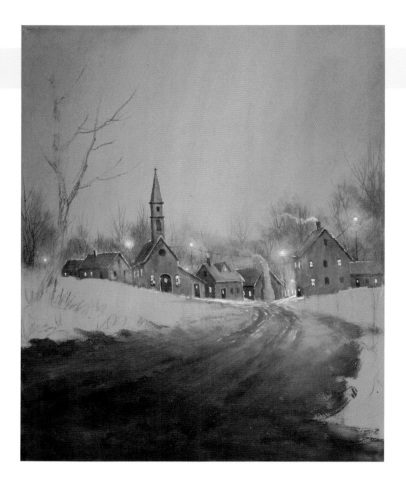

8 Build Up the Light Glow

Mix equal parts white and Cadmium Yellow Light and load a small amount on the tip of a no. 2 bristle flat. Drybrush circular brushstrokes and begin blending a soft glow in the area where the lights are. You can repeat this step more than once to achieve the desired brightness. If you want to have a warmer glow, you can add a touch of Cadmium Orange or Cadmium Red Light to the mixture.

Double load the same colors onto a no. 4 sable script and use short, choppy, broken brushstrokes to carefully apply a thin silver lining along the edge of some of the roofs.

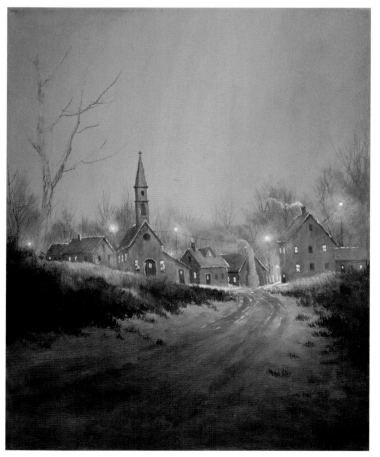

9 Paint the Middle and Foreground Grasses

Mix 2 parts Hooker's Green with 1 part Burnt Umber and 1 part Dioxazine Purple. Use a no. 6 bristle flat to scrub in the middle and foreground grasses with short, choppy vertical brushstrokes.

At the base of the buildings where the glow of light will hit, add Cadmium Yellow Light and Cadmium Orange to brighten the area. Make the color darker as you come forward.

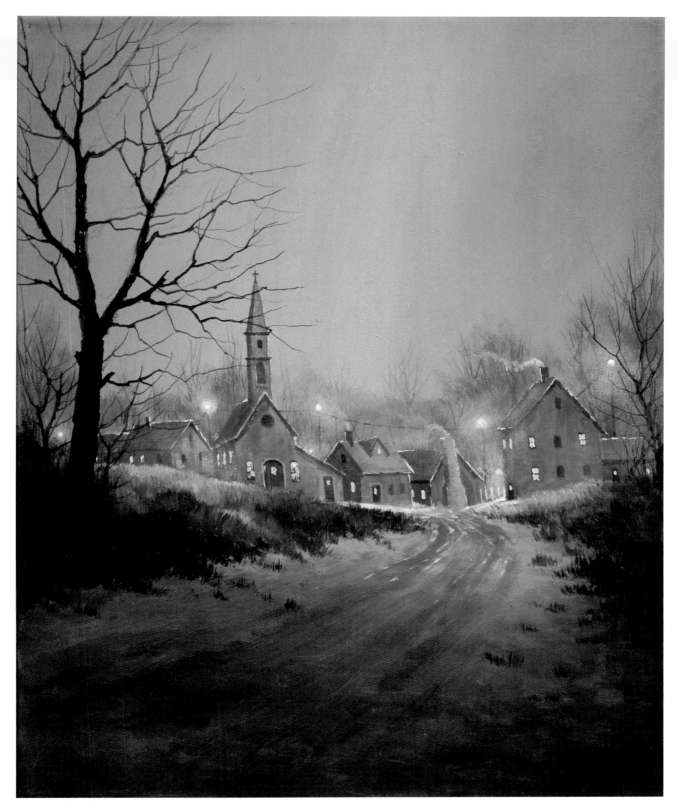

10 Paint the Large Tree

Mix equal parts Burnt Umber and Ultramarine Blue. Add a touch of Dioxazine Purple and make it a creamy consistency. Use no. 2 or no. 4 bristle flat to block in the trunk and main limbs of the large tree. Once you are happy with the basic structure, thin the mixture to an ink-like consistency. Switch to a no. 4 sable script and finish out the smaller tree limbs. Be sure to create interesting pockets of negative space so the tree has good balance and shape.

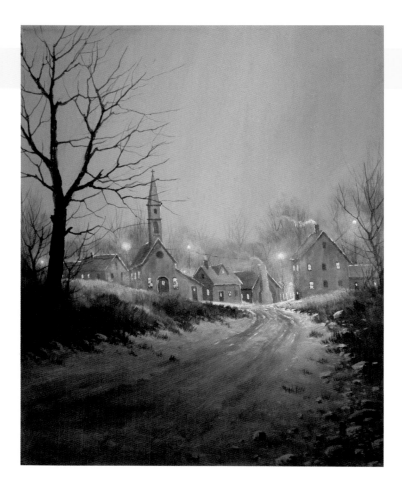

11 Highlight and Detail the Road

Use a no. 4 sable flat to dab in the shape of small rocks along the edges of both sides of the road. Be sure the value is dark enough to just slightly show up against the dirt and grass.

Mix white with touches of Cadmium Orange and Ultramarine Blue and begin highlighting the rocks. Be sure the highlights are brighter toward the bend in the road and slightly darker as you move into the foreground. It is important not to make the highlights too bright in the very front or they will be distracting and overpower the composition.

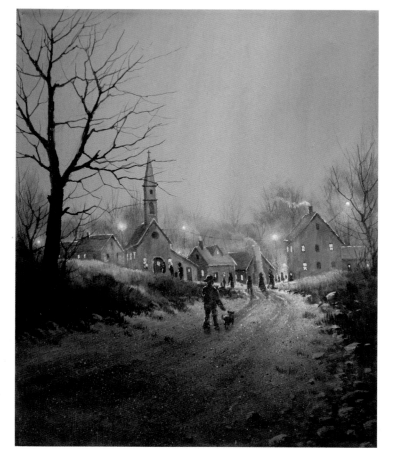

12 Splatter the Road and Add People

Mix white with a touch of Cadmium Orange. Thin it to an ink-like consistency. Load a medium or firm toothbrush and splatter the road to create the suggestion of small pebbles and gravel. The key here is to use a good variety of dark and light values to create contrast. You can also use a variety of colors to add a bit more color balance to the painting.

Adding people to a composition is not as complicated as you might think. These are only silhouettes—simple single stroke figures. Mix equal parts Ultramarine Blue and Burnt Umber. Make it a creamy consistency. Block in the larger part of the main figure with a no. 4 sable flat. Finish the smaller parts and more distant figures with a no. 4 sable round. Then double load a no. 4 sable script with a small amount of white and Cadmium Yellow Light. Carefully apply a broken silver lining on the edges of the figures to help them stand out against the dark background.

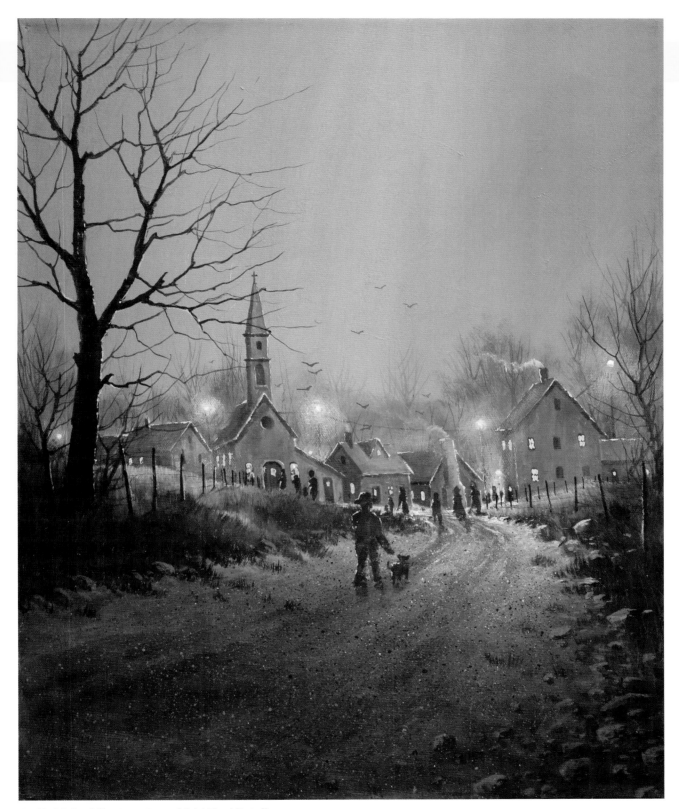

13 Make Adjustments and Add Final Details

Load a no. 4 sable script with the same mixture you used for the figures and paint in the fence posts. Then brighten up the glow on some of the lights in the background. Mix white with a touch of Cadmium Yellow Light and use a no. 4 sable script to add a silver lining on the right side of the large tree. You can paint in a few taller weeds in the foreground and finish with a few distant birds if you like. Just be careful in all of the final steps not to over detail or over highlight. You want to keep the focus on the center of the village where the people are gathering.

Index

About the Author

Jerry Yarnell was born in Tulsa, Oklahoma, in 1953. A recipient of two scholarships from the Philbrook Museum of Art in Tulsa, Jerry has always had a great passion for nature and has made it a major thematic focus in his paintings. He has been rewarded for his dedication with numerous awards, art shows and gallery exhibits across the country.

His awards include the prestigious Easel Award from the Governor's Classic Western Art Show in Albuquerque, New Mexico; acceptance in the top one hundred artists represented in the national Art for the Parks competition; an exhibition of work in the Leigh Yawkey Woodson Birds in Art show and participation in a premier showing of work by Oil Painters of America at the Prince Gallery in Chicago. Some of Jerry's personal fine art pieces can be found in his Oklahoma Studio as well as his online gallery at www.josephyarnell.com. Collectors can be added to his collector-notification list by emailing the Yarnell Studio & School of Fine Art, LLC at jerry@yarnellschool.com.

Jerry has another unique talent that makes him stand out from the ordinary: He has an intense desire to share his painting ability with others. For years, he has held successful painting workshops and seminars for hundreds of people. Jerry's love for teaching also keeps him very busy holding workshops and giving private lessons in his Yarnell Studio and School of Fine Art.

Jerry is the author of sixteen painting instruction books, and his unique style can be viewed on his popular PBS television series, *Paint This With Jerry Yarnell®*, which airs worldwide and is the no. 1 art show of its kind in Canada. Jerry and his wife, Donna, have expanded their world into a thriving Yarnell family community with a following of more than 60,000 students.

The Yarnell Studio & School of Fine Art is home to Donna and Jerry's Yarnell School Online (YSO), which houses the massive new collection of Jerry's instructional materials, making them available via streaming video to thousands of YSO student-members worldwide. Their successful certification programs continue to regularly produce Yarnell Certified Artists™ as well as Yarnell Certified Instructors™, who share and teach Yarnell tried-and-true techniques around the nation.

For more information about the Yarnell Studio & School of Fine Art, LLC., and to order books, instructional videos and painting supplies, contact:

Yarnell Studio & School of Fine Art, LLC.
P.O. Box 1120, Skiatook, OK 74070
877-681-4ART (4278)
Email: jerry@yarnellschool.com
Instructional website: YarnellSchool.com
Online art gallery: JosephYarnell.com

ACKNOWLEDGMENTS

Ms. Donna and I want to thank the thousands of students and viewers of our *Paint This with Jerry Yarnell* ™ television show, who are also members of Yarnell School Online, regulars at my studio workshops and collectors of my personal art pieces. We want to thank Tech Know World, Anello Productions and Universal Media for their strong support through the years. We thank PBS, OETA, RSU TV, NRB, Create TV and all the networks that air our TV shows. We want to acknowledge Merrilou, who works alongside Donna and me at our studio daily. And we certainly want to recognize the North Light Books staff for their continued belief in my abilities.

DEDICATION

First and foremost, I give God all the praise and glory for my success. He blessed me with the gift of painting and the ability to share the gift with people around the world. He has blessed me with a new life after a very close brush with death. I am here today and able to share all of this with each of you because we have a kind, loving and gracious God. Thank you, God, for all you have done.

The next dedication goes to my beautiful bride, Ms. Donna. God brought her into my life several years after my wife Joan passed away. Donna has not only made me a better artist and teacher, she has catapulted the Yarnell Studio & School of Fine Art, LLC into successful proven-growth areas that I once had only daydreamed of having. She is my soul-mate, my best friend and my dedicated partner. With my God and Ms. Donna at my side, nothing is impossible.

a content + ecommerce company

Other fine North Light books are available from your favorite bookstore, art supply store or online supplier. Visit our website at fwmedia.com.

23 22 21 20 19 5 4 3 2 1

Distributed in the U.K. and Europe
by F&W Media International LTD
Pynes Hill Court, Pynes Hill, Rydon Lane
Exeter, EX2 5AZ, UK
Tel: (+44) 1392 797680
Email: enquiries@fwmedia.com

ISBN 13: 978-1-4403-5022-1

Editor: Christina Richards
Designer: Clare Finney
Production Coordinator: Debbie Thomas

METRIC CONVERSION CHART

To convert	to	multiply by
Inches	Centimeters	2.54
Centimeters	Inches	0.4
Feet	Centimeters	30.5
Centimeters	Feet	0.03
Yards	Meters	0.9
Meters	Yards	1.1

Ideas. Instruction. Inspiration.

Receive FREE downloadable bonus materials when you sign up for our free newsletter at artistsnetwork.com/Newsletter_Thanks.

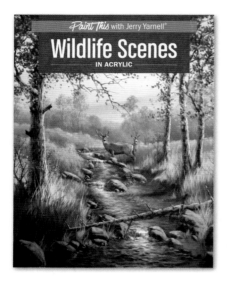

Artistsnetwork
A R T I S T S N E T W O R K . C O M

These and other fine North Light products are available at your favorite art & craft retailer, bookstore or online supplier. Visit our websites at artistsnetwork.com and artistsnetwork.tv.

Find the latest issues of
Artists Magazine on newsstands,
or visit artistsnetwork.com.

Get your art in print!

Visit artistsnetwork.com/splashwatercolor for up-to-date information on Splash and other North Light competitions.

Follow North Light Books for the latest news, free wallpapers, free demos and chances to win FREE BOOKS!